IMAGES of America
HAYMARKET

J,
When in Doubt Dont
Ever forget...
Pobody's Nerfect
...So Proud of you, your own Achievements & The cutest Son our family is likely to Produce
Your Bro -
— Justy Busty

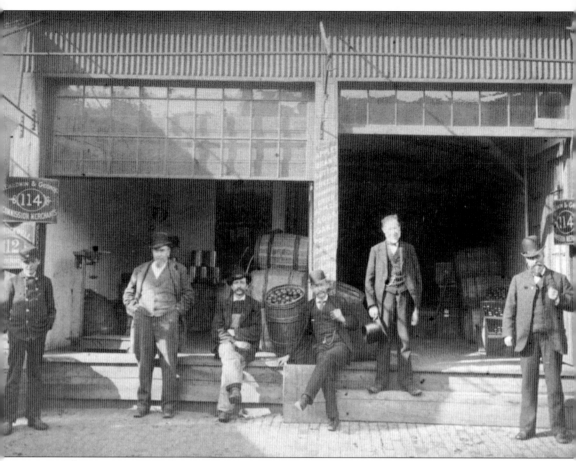

William Sumner Appleton, the founder of the Society for the Preservation of New England Antiquities, now Historic New England, collected this image of Baldwin and George's produce shop at 114 South Market Street. J.W. Baldwin and I.M. George were in business from 1882 to 1887. This peaceful scene shows nothing of the action when the streets were generally crowded with horse-drawn wagons and pushcarts selling and delivering goods along with stacks of barrels and crates and uncollected trash. (Courtesy of Historic New England.)

ON THE COVER: Leslie Jones captured this busy market scene on Blackstone Street in 1940 of young pushcart vendors and customers buying and selling produce. Also pictured are the store fronts, which were a blend of practical merchandise, meat sellers, places to eat, and bars. (Courtesy of the Trustees of the Boston Public Library, Leslie Jones Collection.)

IMAGES of America
HAYMARKET

Justin Goodstein and Kenneth C. Turino
for Historic New England

Copyright © 2015 by Historic New England
ISBN 978-1-4671-3403-3

Published by Arcadia Publishing
Charleston, South Carolina

Printed in the United States of America

Library of Congress Control Number: 2015903567

For all general information, please contact Arcadia Publishing:
Telephone 843-853-2070
Fax 843-853-0044
E-mail sales@arcadiapublishing.com
For customer service and orders:
Toll-Free 1-888-313-2665

Visit us on the Internet at www.arcadiapublishing.com

This book is dedicated to all the past and present Haymarket workers and the people of Boston whom they have served.

Contents

Acknowledgments		6
Introduction		7
1.	Boston's Early Markets	11
2.	The Market District Expands	19
3.	Lewis Hine and the Early 20th Century	31
4.	1920–1950	41
5.	1950s, 1960s, and the Arrival of the Central Artery	53
6.	Wendy Snyder MacNeil's Moment in Time, 1968–1969	69
7.	1969 to the Big Dig	83
8.	The Big Dig Decade, Mid-1990s to Mid-2000s	93
9.	Haymarket Today	101
10.	The Future of the Market District	123
Bibliography		126
About Historic New England		127

Acknowledgments

The authors would like to thank the Haymarket Pushcart Association and the shop owners along Blackstone Street for their support of this project and friendship. In particular, we want to acknowledge Octavio "Otto" Gallotto, president of the association, and Emanuel Gus Serra, the first president of the association, who today acts as an advisor and intermediary with the City of Boston on behalf of the association.

We would also like to thank Boston area photographers for supporting this endeavor with the loan of extraordinary images, particularly Lou Jones, Wendy Snyder MacNeil, and Peter Vanderwarker. The authors are grateful to Caitrin Cunningham of Arcadia Publishing for providing us with an opportunity to publish the first history of Haymarket.

The authors would like to thank the staff at Historic New England, particularly president and CEO Carl R. Nold and Diane Viera, executive vice president and COO, for embracing the Haymarket Project as part of Historic New England's Everyone's History initiative. This book would not have been possible without the assistance of the staff of the library and archives: Lorna Condon, Jeanne Gamble, and Abby Cramer. Kris Bierfelt, Susan Jarvis, and Sarah Jaworski, who helped research and obtain photographic images and rights, also deserve mention.

The staff of many libraries researched and helped us acquire images, particularly Elizabeth Clemens, Walter P. Reuther Library, Wayne State University; Marta Crilly, City of Boston Archives; Chris Donnelly, Rotch Visual Collections, Massachusetts Institute of Technology; Anna Jedrzejowski, Ryerson Image Centre, Ryerson University; and Aaron Schmidt, Boston Public Library.

Justin would like to thank his wife, Marina, for her encouragement, good company, patience, love, and support of his projects. He also is grateful to Danny Baxter for his unwavering support, advice, and help on each endeavor, no matter how complex. Special thanks go to his mother, Ingrid Marie Aue, who gave him the strength, support, and will to go on—teaching him to always give his best. Bernie and David Goodstein, this work is dedicated to you.

Ken would like to thank Chris Mathias for his continued help and most of all his patience. Thanks also go to Anthony Sammarco for his encouragement and help with this project.

INTRODUCTION

This publication on Haymarket, Boston's open-air produce market, grew out of Historic New England's Everyone's History Project, an ongoing exploration of life in New England. Historic New England partnered with the Haymarket Pushcart Association to document Haymarket's vendors, workers, and customers through Justin H. Goodstein's black-and-white photographs and oral history interviews conducted by Kenneth C. Turino. The project resulted in a series of online films, which evolved into a traveling photographic exhibition, *Haymarket, The Soul of the City*, and a documentary film of the same title, which premiered in July 2015.

Although much has been written about Boston's early markets, surprisingly little has been written about Haymarket. Up until the first half of the 20th century, the area that now encompasses Haymarket was typically referred to as the market district. It included Faneuil Hall and Faneuil Hall Market, popularly known as Quincy Market, and the streets and squares adjacent to them. The name Haymarket derives from Haymarket Square, it having been the location of one of several public scales used for weighing hay for sale. Haymarket Square was at one end of the market district, which ran from Faneuil Hall and Faneuil Hall Market along Blackstone Street.

Boston's earliest settlers were served by peddlers with carts going about the town selling produce and meat. Boston's first outdoor produce and meat market was established around the town dock, the chief place for trading and storing goods. It was near the present site of the Sam Adams statue on the west side of Faneuil Hall. An open-air fish market was located north of the town dock. In 1734, the town voted to establish three markets: one at Dock Square, one in North Square in the North End, and one at South Market on Boylston Street near the present-day intersection of Boylston and Washington Streets. Owing to citizen discontent with an organized and regulated market system, these three markets lasted only three years.

Merchant Peter Faneuil offered at his own expense "to Erect and Build a noble structure or Edifice, to be Improved for a Market, for the Use, Benefit, and Advantage of the Town." Faneuil Hall was completed in 1742, but vendors were slow to rent space in this market, and it was forced to close several times. Residents of the town preferred the pushcarts that roamed the city. The original structure was all but destroyed in a fire on January 31, 1761. The town soon after voted to rebuild the structure, and it reopened on March 14, 1763. This time, the market was a success. Residents of the growing city now appreciated the convenience and benefits of a centralized market with regular hours. Faneuil Hall Market followed in 1826. Conceived by Mayor Josiah Quincy, the marketplace's purpose was to relieve the crowded and unsanitary conditions in the market district. Over the course of three years, Quincy worked closely with the city council and the market committee to raise funds to purchase land and build the market. The work included acquiring buildings and wharves and filling in part of the harbor. The plan for the new marketplace also called for the construction of two long buildings (North and South Markets) for use as merchant stores. The initial plan for the market was developed by architect Asher Benjamin but drastically altered and enlarged when Alexander Parris became the chief designer. With the development of

Faneuil Hall Market, Boston's market district came into its own. The area around Dock Square, Adams Square, North and Clinton Streets, and Atlantic Avenue became the center of the city's expanding food-merchandising industry.

The district expanded about 1833 with the development of Blackstone Street. The expansion required the filling of Mill Pond and its tributary, the Mill Creek, with fill from the leveling of Beacon Hill, the removal of buildings, and the reduction of lots within the Blackstone Block. New buildings along Blackstone Street were typically four or five stories tall. Buildings that had once had their backs to Mill Creek were reoriented to face the new street.

Haymarket Square was laid out by 1839 and quickly became a center for commerce, particularly because of its proximity to the Boston & Maine Railroad terminus. Building on Blackstone Street continued over the next 20 years. In the 1850s, businesses along Blackstone Street were predominately related to the manufactory of stoves, but over time, more and more food-related businesses moved into the area.

As the city expanded and the population grew, there was a demand for more neighborhood markets. Some 20 market buildings existed in the 1870s, including the Blackstone Market, which first appeared in 1852. Also, in the 1870s, a major fish market was located on T-Wharf, and a farmers' market was on Mercantile Street. Even with the building of neighborhood markets and the expansion of the market district, peddlers continued to roam the neighborhoods, particularly in the north, south, and west ends of the city. These peddlers used handcarts and later pushcarts to sell their wares. After numerous complaints about peddlers, in 1899 Boston required that "every peddler engaged in selling in the public street will be registered and furnished a number." A *Boston Globe* article from August 22, 1904, on the history of pushcart peddlers estimated that a generation before, there were less than 100 peddlers. By 1904, there were nearly 800 peddlers, mainly Greek and Italian immigrants. The market and peddlers catered not only to the established population, but also to the growing numbers of immigrants. The market tradition of offering good-quality but low-priced meat, fish, and produce to people from all walks of life, particularly low-income residents, nearby office workers, students, and new immigrants, continues to this day.

Newspaper accounts from the early 20th century are filled with reports of encounters between pushcart vendors and police over the blocking of streets, sidewalks, and passageways. Starting in 1908, the police were charged with clearing all fruit and vegetable stands from downtown sidewalks and streets. The new laws enacted at that time allowed for pushcarts and stands to be only on Blackstone Street from Haymarket Square to North Street, the north side of North Street from Blackstone to Union Street, the west side of Merchants Row from North Street to Faneuil Hall Square, the north side of North Market Street, and the north side of Faneuil Hall Square.

Other factors were at work that would have a profound effect on the market district. According to a *Boston Globe* article from September 1968, "The new Century saw the decline of Boston markets. As food retailers organized into chains, and as meat packers grew into national concerns, the need for independent small merchants diminished." In 1948, a headline in the *Boston Globe* read, "It's Too Tough Even for Horses at City's Market." The accompanying article details the proposal by Boston mayor James Michael Curley to address concerns about the welfare of the horses by banning them from the market district. It was estimated that there were approximately 60 horses, many of them stabled and rented out daily from the North End. This began the decline of using the horse as transportation. Some were still to be found in the market district as late as the 1950s. Ultimately, the reliable horse would be replaced in the market district by the motorized truck.

A short-lived Boston Pushcart Association was formed in 1941, and on their first anniversary, 287 members celebrated with a banquet at the Coconut Grove, a popular Boston nightclub. A *Boston Globe* article of April 29, 1942, commenting on the event reported, "Pushcart business is big business. The average pushcart peddler in the market district takes in $100 on a Saturday and $30 every weekday. They do more than $5,000,000 worth of business in Boston every year." The second half of the 20th century saw even greater changes to the market district. In 1948, the Massachusetts Department of Public Works initiated the Master Highway Plan for the Boston Metropolitan Region, which included the building of the Central Artery. In the 1950s, one half

of Blackstone Street was demolished for the Central Artery. At this time, Quincy Market was in decline, with many vendors forsaking the market for other locations. Historian John Quincy described the marketplace in the 1950s as "a dank collection of modified warehouses/stores that gave off the unsettling odor of rotting fish, flesh, and fowl from uncollected trash." By the late 1960s, wholesalers who had shops at Quincy Market and Faneuil Hall had moved into the New England Produce Center, a new distribution center in Chelsea, Massachusetts. By this time, Haymarket was mainly made up of vendors and workers of Italian descent selling produce from their pushcarts. These sellers had a reputation for being rude and selling overripe produce, but they did a public service by providing the produce at a fraction of its price at the grocery store.

In 1974, pushcart peddlers and shop owners along Blackstone Street organized as the Haymarket Pushcart Association in order to push the city to improve conditions for the vendors and the public, including better traffic control and regular garbage removal. Emanuel Gus Serra, a state representative from East Boston and son of an owner of a Haymarket produce stand and worker there himself, became the first president (for one year) and to this day is still the chief negotiator between the association and the city. Joseph Matera, who began at the market in 1943, succeeded Serra as president in 1975 and ran the organization until Ottavio "Otto" Gallotto became president in March 2004. Matera then became the spokesperson for the association, addressing issues with the city's health department or with the Commonwealth of Massachusetts. In the mid-1970s, much of Matera's work with Gus Serra's assistance dealt with trash pickup at the market. The then mayor Kevin White threatened to discontinue trash pickup at the market owing to its high cost to the city. With the aid of longtime Haymarket supporter city councilman Frederick Langone, the Haymarket Pushcart Association and the city eventually reached a compromise, which included regular trash pickup by the city and raising license fees for the pushcart vendors to help offset the cost of trash cleanup.

Development pressures continued to challenge the market, an example being the proposal to build the Millennium Bostonian Hotel at the corner of North and Blackstone Streets. One of the Boston Redevelopment Authority conditions for construction called for the hotel not to interfere with the pushcart trade. The hotel opened in September 1982, at which time the present configuration of the market was set. Today's market runs along Blackstone Street between North and Hanover Streets, Hanover Street to Union Street, and halfway up North Street to the entrance of the hotel. In the past, the pushcart vendors were found all along this block of North Street.

The next major challenge facing the market was the plan to depress the Central Artery into the Thomas P. O'Neill Jr. Tunnel. Known as the Big Dig, the project also included the construction of the Ted Williams Tunnel, the Leonard P. Zakim Bunker Hill Memorial Bridge over the Charles River, and the Rose Kennedy Greenway. Construction took place between 1991 and 2006, with the project officially ending on December 31, 2007. The Haymarket Pushcart Association negotiated with the city for a guarantee that the market would operate Fridays and Saturdays during the life of the project. In fact, construction halted by Thursday afternoon, allowing vendors to set up their stands. Frederick Salvucci, secretary of transportation during the initial planning of the Big Dig, worked with the association and Gus Serra to maintain the market. He made sure that the market continued to function throughout the entire Big Dig Project. When Haymarket was threatened with a loss of parking, Salvucci pushed through mitigation with the federal government that provided parking (at a reduced rate when stamped by the vendors) in the Parcel 7 Garage, at the intersection of Congress Street, Hanover Street, Sudbury Street, and Blackstone Street, an arrangement that continues to this day. When completed, the Big Dig created new challenges, including the proposed development of reclaimed land. Parcel 9, a triangular slice of vacant land bordering the Rose Kennedy Greenway and Blackstone Street, is slated to become a hotel. Currently, that site holds the trash compactors for the market, and their removal will seriously impact the market.

In July 2015, the market district, with the support of the City of Boston and the Haymarket Pushcart Association, experienced its first major expansion in almost a century with the opening

of the Boston Public Market at 100 Hanover Street. This market is the only one of its kind, offering for sale goods produced or originating in New England.

Haymarket plays a vital role in the city, supplying inexpensive produce to customers from all walks of life. It is an important part of Boston that both locals and tourists seek out, and it must be preserved. Today, Haymarket still includes the Italian American vendors that made up the market nearly a century ago as well as halal butchers, artisanal cheese mongers, and Cambodian fruit sellers. Thanks to the Haymarket Pushcart Association and its president Otto Gallotto, conditions at the market continue to improve. Onsite trash collectors have greatly added to the cleanliness of the market. The vendors, formerly Italian American for the most part, are now a more diverse group of sellers. More and more of the vendors, workers, and customers come from Central America, the Middle East, Russia, and Asia. Some are recent immigrants, some the children of immigrants. The food, too, has changed to reflect the changes in the demographics of both Boston and the region. Today, Haymarket is open Fridays and Saturdays from dawn to dusk and continues to serve an ever-changing and diverse population. As Otto Gallotto has said, "I want people to understand that this market has to survive, one way or another. People need this market. It's not just for the poor, it's for everyone."

One
BOSTON'S EARLY MARKETS

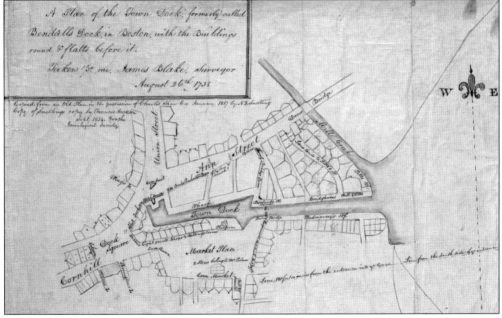

Boston's earliest outdoor open-air market, called the Corn Market or Dock Market, was at the town dock, the center of Boston's commerce. The dock is seen in the center of this 1735 map. In 1734, the town voted to establish three markets. This map shows the location of the Centre Market, which had been the Corn Market by Dock Square. The other markets were located in North Square in the North End and South Market on Boylston Street by the present-day intersection of Boylston and Washington Streets. Due to contention among residents who did not like an organized and regulated market system, these three markets lasted only three years. (Courtesy of the Norman B. Leventhal Map Center at the Boston Public Library.)

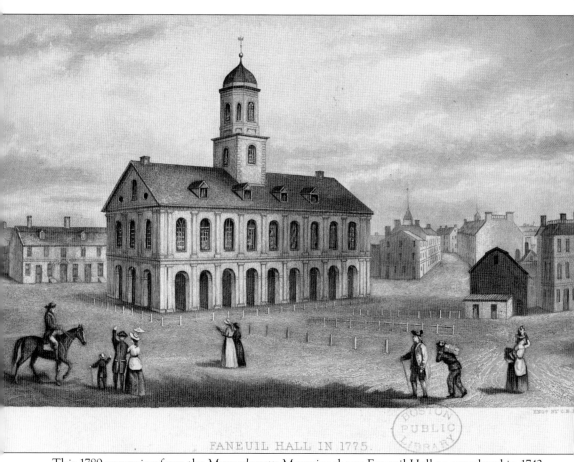

FANEUIL HALL IN 1775.

This 1789 engraving from the *Massachusetts Magazine* shows Faneuil Hall as completed in 1742. Merchant Peter Faneuil offered at his own expense to build a public market. After some debate, the building, designed by the artist John Smibert and named in Peter Faneuil's honor, was erected. The market stalls, located in an open arcade on the ground floor, sold meat, fish, and produce. The second floor consisted of a large hall for town business and public meetings. Vendors were slow to rent space, and the market was forced to close several times. Residents of the town preferred the pushcarts that roamed the city. The original structure was all but destroyed in a fire on January 31, 1761. (Courtesy of Historic New England.)

Soon after the devastating fire of 1761, the town voted to rebuild the structure. The building reopened on March 14, 1763, and this time it was a tremendous success. Residents of the growing city now appreciated the convenience of a centralized market with regular hours. This engraving from Caleb Snow's *A History of Boston* (1828) shows the building as it looked after an 1805 renovation by architect Charles Bulfinch when it was extended by 80 feet with the third story and basement added. To the right of the building is the Shambles, a market where fish and produce were sold and butchers openly slaughter animals for meat. (Courtesy of Historic New England.)

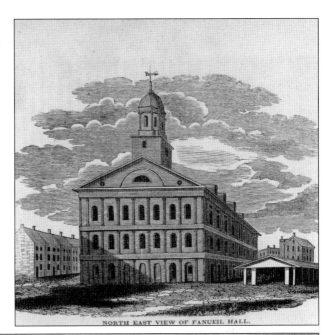

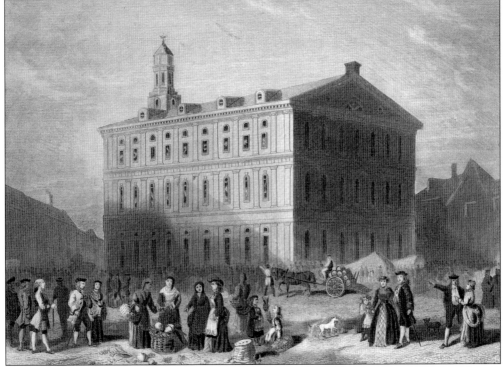

This engraving from about 1830 depicts Faneuil Hall as part of the bustling market district with people passing by, shoppers, and vendors selling their wares. The second-floor hall in the original building was an assembly hall for the town. The renovation increased its height and included the addition of galleries around the hall. The Ancient and Honorable Artillery Company of Massachusetts, the oldest chartered military organization in North America, has had its headquarters in Faneuil Hall since 1746. (Courtesy of Historic New England.)

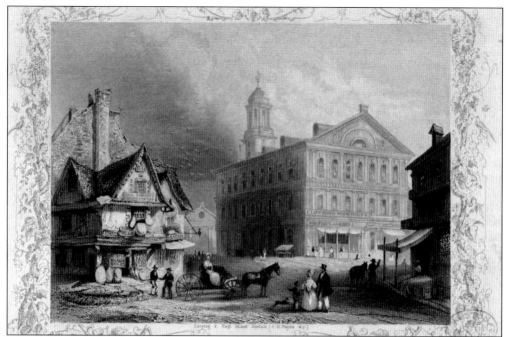

Dock Square, bounded by Congress, North, and Union Streets and adjacent to Faneuil Hall, was a center for commerce because of its proximity to the town dock. By 1733, a short-lived market building had opened, but it was destroyed in 1737 by a mob opposed to the regulation of markets in the town. Boston's iconic Old Feather Store and Faneuil Hall can be seen in this engraving from around 1840. The Old Feather Store, built in 1680 and demolished in 1860, housed a succession of businesses, including a hat maker, apothecary, and, of course, a seller of feathers. By the 1840s, as evidenced by the sign on Faneuil Hall, the marketplace also housed a variety of shops, including a clothing warehouse. (Courtesy of the Trustees of the Boston Public Library.)

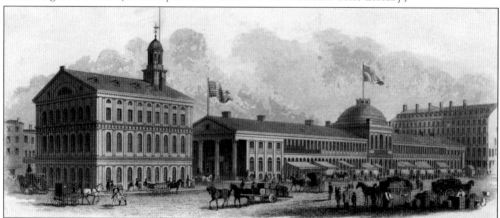

This 1830 engraving depicts Faneuil Hall and Faneuil Hall Market, popularly known as Quincy Market. The marketplace was built on filled land. Conceived by Mayor Josiah Quincy to relieve the crowded and unsanitary conditions in the market district, it took three years to develop the site as a produce and foodstuff shopping center. Quincy worked tirelessly with the city council and market committee to acquire the necessary funds to purchase land and build the market. This included acquiring buildings and wharves and filling in the harbor. (Courtesy of Historic New England.)

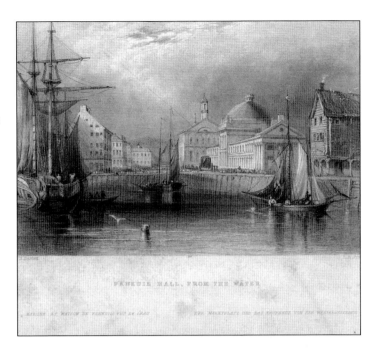

This engraving published in *American Scenery* (1839) captures Faneuil Hall Market from the waterfront. The original plan for the market by architect Asher Benjamin was drastically changed and enlarged when Alexander Parris became the chief designer. The market opened without any ceremony on August 26, 1826, and instantly became a tremendous success. (Courtesy of the Trustees of the Boston Public Library.)

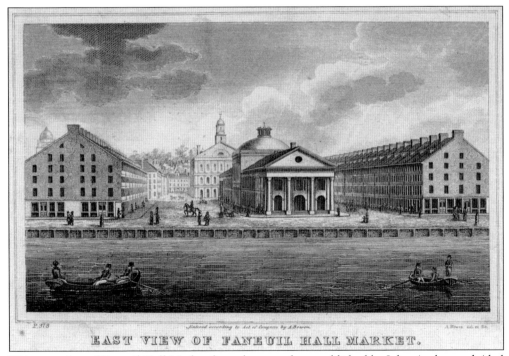

This east view of Faneuil Hall Market from the waterfront published by John Andres and Abel Bowen in 1837 shows the central market, flanked by two long buildings (North and South Markets), each 4.5 stories high, occupied by merchant stores. When these stores opened, most merchants sold dry goods. Designed by Alexander Parris, the warehouses were built with the same granite material as the central market. (Courtesy of Historic New England.)

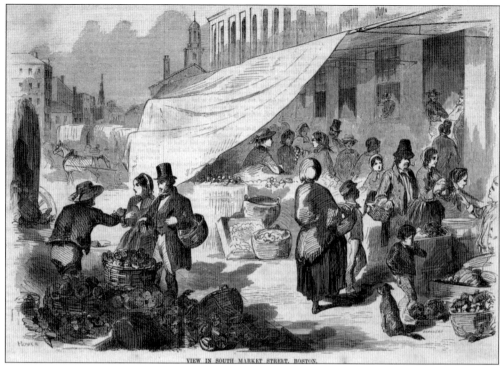

This image by Winslow Homer appeared on the cover of *Ballou's Pictorial Drawing Room Companion* on October 3, 1857. It shows the bustling market outside Faneuil Hall Market where pushcart and wagon vendors were allowed to sell their goods, without any charge, in the streets flanking the market. The first story of the market building contained a grand corridor lined on either side with stalls selling produce, butter and cheese, fish, and meat. Below the market was a cellar for storage and above a vast hall called Quincy Hall for assemblies, which later was divided into apartments used as warehouses. (Courtesy of the Trustees of the Boston Public Library.)

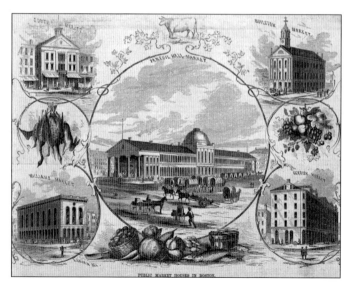

"If the good people of Boston die of starvation, it will not be for the lack of well supplied market houses" began the article on Boston's markets accompanying this engraving from *Ballou's Pictorial Drawing Room Companion* on August 18, 1855. Pictured here are several markets catering to different Boston neighborhoods. As the city expanded and the population grew, there was a demand for more neighborhood markets. (Courtesy of Historic New England.)

The Boylston Market opened in 1810 at the corner of Boylston and Washington Streets on the site of one of the three original Boston markets. The building was named for Ward Nicholas Boylston, a merchant and philanthropist who donated the clock on the tower. The engraving below, from about 1850, illustrates the varied uses of the building, from a tailor shop to a gymnasium and a market. While vendors on the ground floor sold produce and meat, peddlers sold their goods on the street. Boylston Hall, located on the floor above the market, hosted a "variety of musical, theatrical and miscellaneous entertainments." (Both, courtesy of Historic New England.)

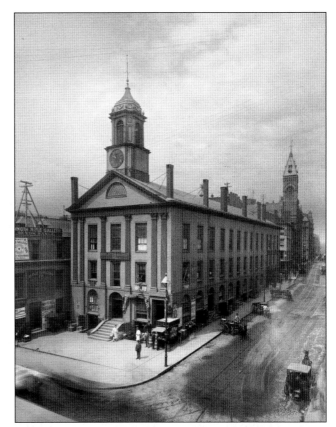

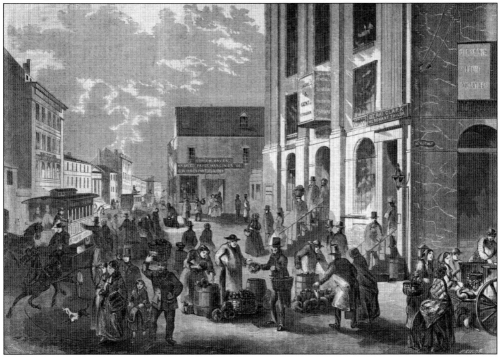

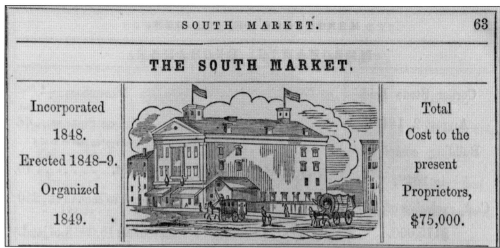

The South Market, also called the Beach Street Market, was located on Beach Street between Lincoln and South Streets. Built in 1849, it contained 38 stalls on the first floor. Twenty sold meat (a staple of the diet at that time); seven, vegetables and fruit; six, butter and cheese; two, fish; and the remaining were vacant. Its proximity to the Western Railroad assured a great variety of produce. The upper story was used for theatrical performances. (Courtesy of Historic New England.)

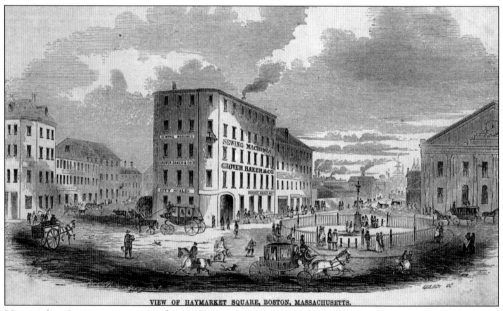

Haymarket Square, as seen in this 1852 engraving, originally part of Mill Cove, was laid out in 1839 and became a center for commerce because of its proximity to the Boston & Maine Railroad. The name derives from its having been the site of one of several public scales used for weighing and selling hay. Boston's first "engine for weighing of hay brought to market" opened in 1739. According to an 1872 *Boston Daily Globe* article, "Years ago every week day morning Canal Street would be lined with loads of hay and wood from the country." These loads of hay were brought in by teamsters, stableman, and truck men of the city. (Courtesy of Historic New England.)

Two
THE MARKET DISTRICT EXPANDS

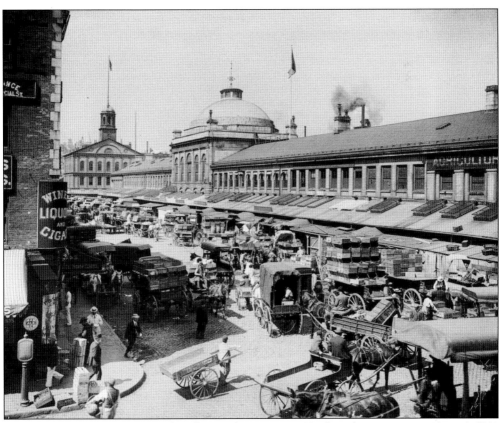

Faneuil Hall Market and Faneuil Hall were thriving in 1908 when this image was taken. A 1910 pamphlet on the market stated, "Faneuil Hall Market which because of its close connection with Faneuil Hall, has become not only a land-mark but a source of pride to our citizens. The sight of three to four hundred wagons loaded with fruits and vegetables . . . the competition of the farmers in their efforts to sell their produce; the hustle and hurly-burley of the purchasers who represent the commission dealers, hotel, and provision stores, as well as of the poorer classes who are looking for bargains and an opportunity to buy something cheap, is a sight well worth the time." (Courtesy of Historic New England.)

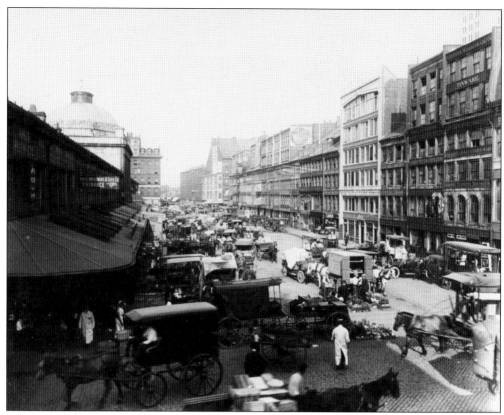

This view of a crowded South Market Street was photographed by William Clark in the 1920s. Market Street, at 102-feet-wide, offered room for the growing number of street vendors, vehicles both horse and motor driven, and customers. The awnings and business signs began to appear on the buildings in 1850s. The addition of several stories to the South Market obscured Alexander Parris's original design. Note the large number of seed stores and agricultural warehouses that proliferated at this time. (Courtesy of Historic New England.)

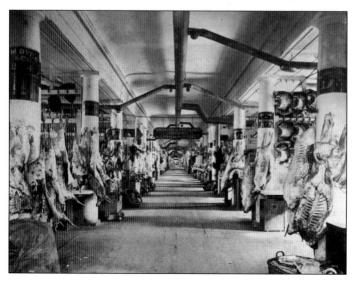

According to historian John Quincy Jr., the vendors at Quincy Market sold predominately beef, both wholesale and retail, after the Civil War, as this 1860s photograph by D.W. Butterworth attests. "Livestock from Canada, New York, and the western states was shipped to the stockyards at Brighton, Massachusetts, where the cattle was slaughtered and shipped to the market house." (Courtesy of Historic New England.)

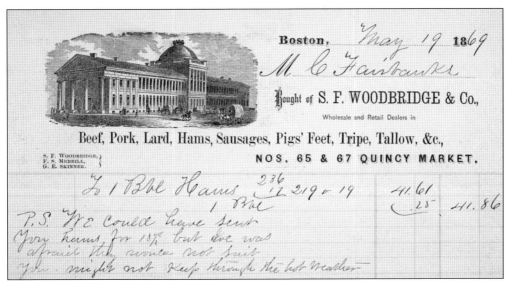

On May 19, 1869, S.F. Woodbridge & Co., located at 65 and 67 Quincy Market sold hams to C. Fairbanks. The billhead indicates the company specialized in beef and pork products. The preponderance of meat vendors in the market gave the impression to the public that they were monopolizing the trade and price-gauging. After public hearings on pricing at the market, a study commissioned by the city found prices were below those of other major cities. (Courtesy of Historic New England.)

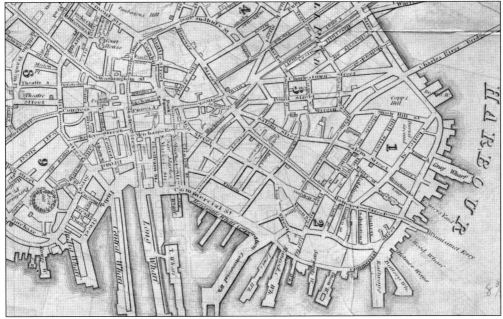

This 1835 plan of Boston by Charles Stimpson is the first map to show Blackstone Street. Following the filling of Mill Pond with soil from the leveling of Beacon Hill, Blackstone Street was laid out by 1833; it became the west border of the 2.3 acres of the Blackstone Block bounded by Union, Hanover, and North Streets. An early commercial and industrial center, the Blackstone Block is notable for the survival of the 17th-century street pattern in the interior of the block where six lanes survive. (Courtesy of the Norman B. Leventhal Map Center at the Boston Public Library.)

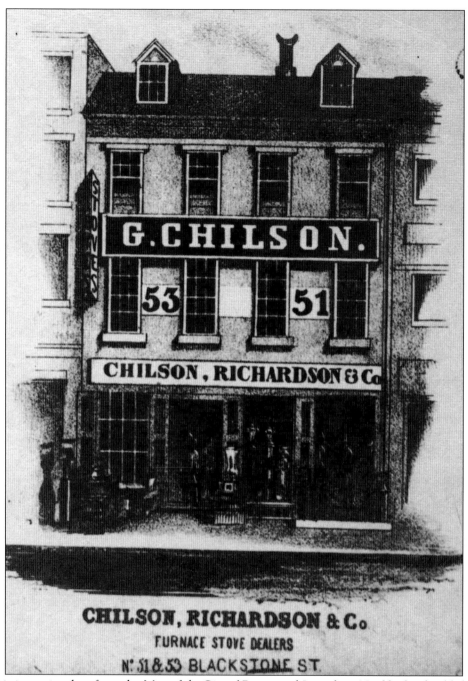

This image is taken from the *Map of the City of Boston and Immediate Neighborhood* published by Henry McIntyre in 1852. With the inclusion of images of individual structures, the map gave evidence of the city's prosperity. According to the 1850 census, Boston had a population of almost 137,000, making it the third-largest city in the United States. This image and the one on the opposite page are among the earliest of Blackstone Street. Chilson, Richardson & Co. began selling stoves in 1838 on Hanover Street, moving to 51 and 53 Blackstone Street in 1842, where they remained until 1852. (Courtesy of Historic New England.)

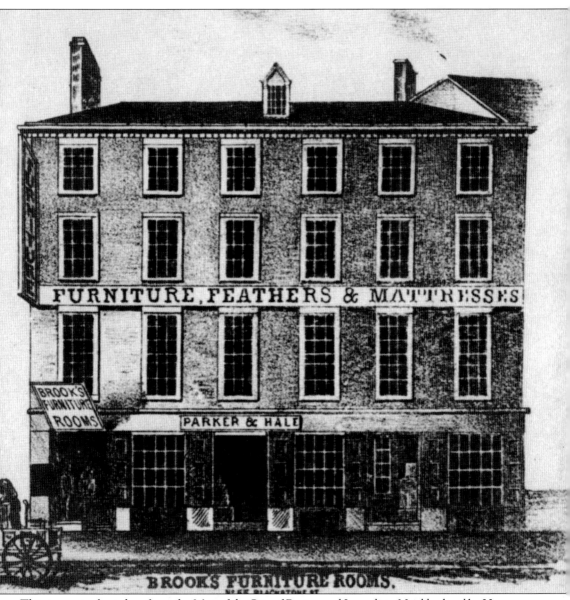

This image is also taken from the *Map of the City of Boston and Immediate Neighborhood* by Henry McIntyre. William P.B. Brooks went into business as the Brook's Furniture Rooms in 1833, moving to 66 Blackstone Street in 1841 or 1842, where it remained until 1852 before moving to another location on Blackstone Street. (Courtesy of Historic New England.)

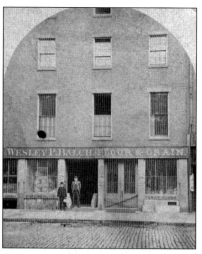

This image of the Wesley P. Balch Flour & Grain business was taken by Rand & Bird, landscape photographers of South Boston. The Balch company began in 1863 at 67 Commercial Street and moved to 28 Blackstone Street in 1865, where it remained until 1879. The structure is typical of the common-bond brick buildings with straight brownstone lintels usually four or five stories tall that were found along Blackstone Street. (Courtesy of Historic New England.)

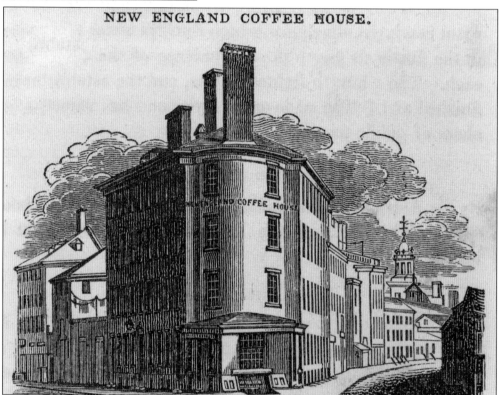

Luxury hotels are not new to the market district. The New England Coffee House, on the corner of Blackstone and Clinton Streets, opened on July 24, 1832, and was illustrated in *Bowen's Picture of Boston* in 1838. The public house was built on a triangular piece of land about 10,000 square feet. It was described as having "a convenient bar and news room, a large dining hall, 16 feet wide by 70 long, a suitable number of parlors and sitting rooms and about 80 sleeping chambers. The kitchen and cooking apparatus is most admirably contrived. In the washroom is a hydraulic pump, which conveys water to a reservoir in the fourth story for the convenience of the apartments in each." Lit by gas and "furnished in good style," the public was well served. (Courtesy of Historic New England.)

This photograph was taken of 83–95 Blackstone Street about 1876 or 1877, the only years when all the businesses seen in the image were at this location. By this time, the makeup of businesses in the block was in transition, with fewer tinware manufactories and stove dealers. In 1861, of the 60 such businesses in operation in the city, almost one-third were located in the Blackstone Block. By 1877, with the growth of the city, there were 111 business with only 16 located in the Blackstone Block. (Courtesy of Historic New England.)

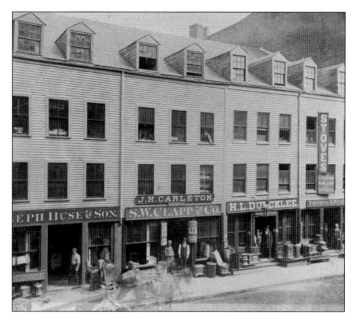

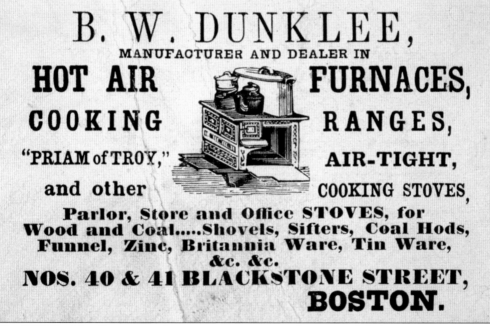

The B.W. Dunklee Company, a long-running stove manufacturer and dealer, was representative of the many such businesses along Blackstone Street. The company first appears in the *Boston Directory* in 1851 on Blackstone Street. They moved frequently on the street until 1861, when they relocated to numbers 111 and 113, remaining there until 1875. In 1868, advertisements proclaimed the company as the inventor of the Golden Eagle Furnace, the Beauty Cooking Range, and the Silver Bell Cooking Stove. Successors to that company, the Dunklee Company and the G.C. Dunklee Company, remained in the same location into the 1880s. (Courtesy of Historic New England.)

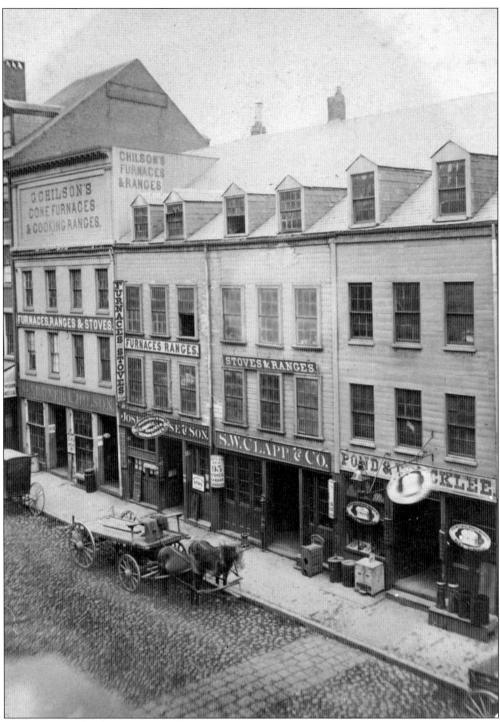

This photograph showing the stove, range, and furnace businesses along the cobblestone-lined Blackstone Street was taken before 1874. The unpretentious buildings were typical of the four- or five-story buildings that were constructed after the street was laid out about 1833. (Courtesy of the Trustees of the Boston Public Library.)

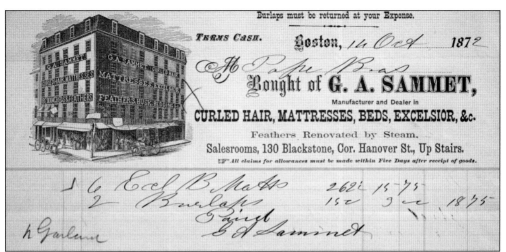

George Sammet began his long career as an upholster in 1853. By 1866, he had opened a business specializing in bedding at 130 Blackstone Street, at the corner of Hanover Street. An 1866 advertisement in the *Boston Directory* stated that the company was a dealer and manufacturer of mattresses and bedding and made pew cushions for churches. George Sammet eventually brought his son George W. into the family business. This billhead dates to the last year the company was at this location; they moved in 1873 to Merrimac Street and then to 154 Hanover Street, where they remained until 1902, when they moved to 57 Hanover Street. The company was in business until 1916, having moved to 8 Atlantic Avenue between 1904 and 1905. (Courtesy of Historic New England.)

Today, the Blackstone Block encompasses a collection of 18th-, 19th-, and 20th-century buildings. This photograph shows the Ebenezer Hancock House, located at the corner of Marshall Street and Creek Lane, one of two 18th-century structures to survive on the block, the other being the Union Oyster House. John Hancock built the house after 1767 and before 1776, by which time his brother Ebenezer occupied it. The house served a variety of domestic and commercial uses. Just beyond the house is the Boston Stone. The area's ongoing commercial importance in the 18th century is attested to by the location in the block of the Boston Stone seen embedded at the base of the building to the left. It was placed there in 1737 and served as a zero milestone from which distances to Boston were measured. (Courtesy of Historic New England.)

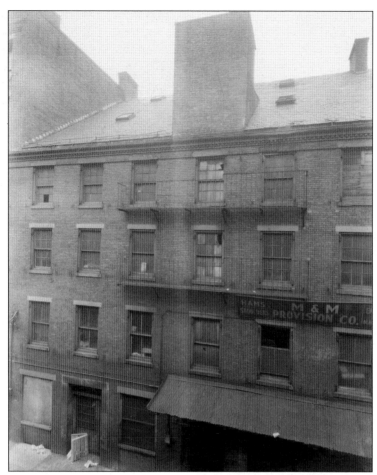

According to Miguel Gomez-Ibanez, the laying out of Blackstone Street required removing buildings and reducing the size of lots. Along with new construction, buildings that had once had their backs to Mill Creek were reoriented to face the new street. This may be true for the building in this photograph, which housed the M & M Provision Company whose entrance was on Blackstone Street. The company first appears in the 1931 *Boston Directory* and was listed at 88 Blackstone Street through 1947. (Courtesy of Historic New England.)

In the 20th century, more and more provision and food-related businesses began to appear on Blackstone Street. This brochure for Frostlene pastry frosting was printed in 1902 or 1903, when the Frostlene Manufacturing Company was located at 53–55 Blackstone Street. The company advertised "much goodness for little money" and "extracts and specialties," offering flavors from old standbys like chocolate and vanilla to their newest, Angelica. The company moved to another location on Blackstone Street in 1906 and had ceased operating by 1907. (Courtesy of Historic New England.)

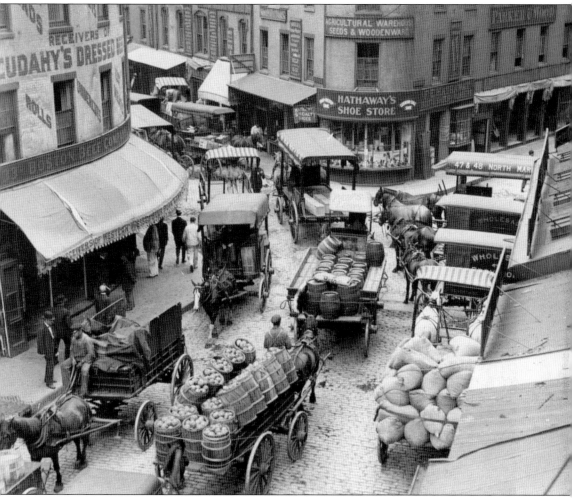

This image of the corner of Merchants Row and North Street shows just how busy the market district could be. Complaints about congestion date back to at least 1825 when a *Boston Gazette* noted, "On certain business days the jam is intolerable." This photograph dates to about 1885, when the F.E. Hathaway Shoe Store (center) and the business to the right, Parker and Wood, were located here. Parker and Wood was an agricultural warehouse and seed store that specialized in "everything for the farm, garden and lawn" according to an advertisement in the 1885 *Boston Directory*. Merchants Row originally ran between State and North Streets, but this block along North Street was taken down for the East Boston Tunnel. (Courtesy of the Trustees of the Boston Public Library.)

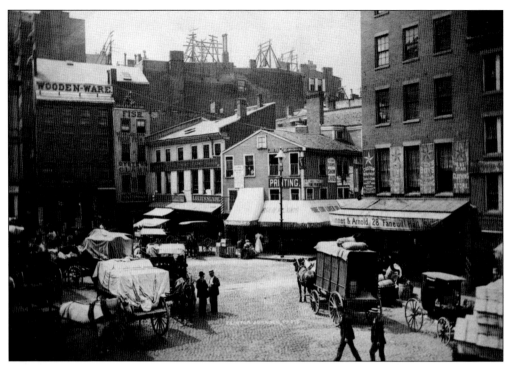

These two images of the intersection of Faneuil Hall Square and Dock Square show the changes to the market district that took place in the late 19th and early 20th centuries. In the center of the above photograph, taken by Clinton Johnson about 1895, is the wooden-frame Marshall Johnson Fish Store with a printing office above. Marshall Johnson moved to 24 Dock Square in 1888. On the left, the sign for Lucius Slade, who sold butter, cheese, and eggs, is visible. Another fish store, Joel E. Foster and Company, can be seen to the left of this establishment. The Johnson Fish Store and the buildings to its immediate left were replaced with a brick structure between 1908 and 1912, as seen in the photograph below. (Above, courtesy of the Library of Congress, LC-USZ62-96212; below, courtesy of the Trustees of the Boston Public Library.)

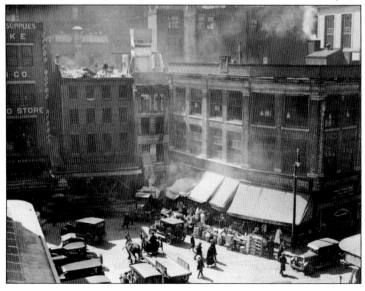

Three
LEWIS HINE AND THE EARLY 20TH CENTURY

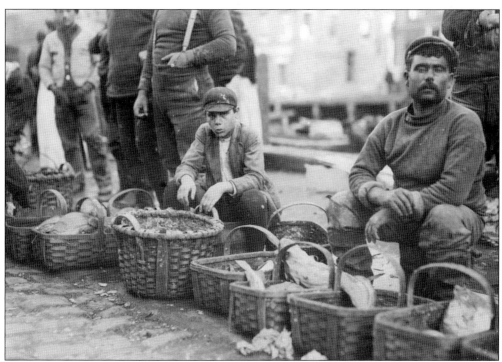

All the photographs in this chapter were taken by noted photographer Lewis Hine (1874–1940). They were made in October 1909 or January 1917. A 1904 article in the *Boston Globe* on the history of Boston's pushcart peddlers discusses the influx of immigrants "from countries bordering the Mediterranean," particularly the Italians. The article describes how the peddlers went about the city selling their baskets of goods. (Courtesy of the Library of Congress, LC-DIG-nclc-03320.)

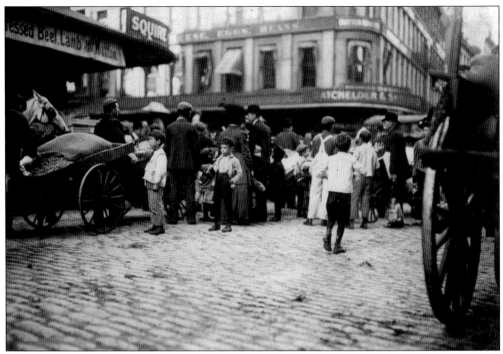

Pedestrians crowd the street in this October 1909 photograph. Vendors in the shops, wagons, and pushcarts all vied for the business of the passersby. On the left is the shop of John P. Squires and Sons, wholesale and retail dealers in beef, pork, lamb, veal, and poultry. Their advertisement in the 1909 *Boston Directory* states, "Hotels, Steamships, Clubs, Restaurants, and Family Trade a Specialty." On the right at 55 Blackstone Street is Batchelder and Synder Co., dealers in provisions. (Courtesy of the Library of Congress, LC-DIG-nclc-04534.)

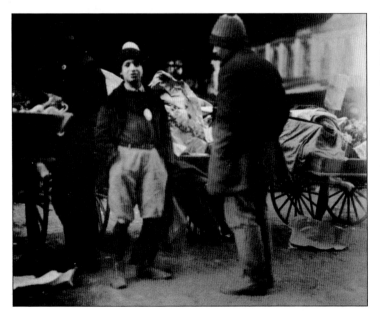

In 1908, Lewis Hine became the photographer for the National Child Labor Committee (NCLC), a leading proponent for child labor reform. After joining the committee, Hine wrote, "My child-labor photos have already set the authorities to work to see if such things can be possible. They try to get around by crying 'Fake' but therein lies the value of the data and a witness." (Courtesy of the Library of Congress, LC-DIG-nclc-03997.)

Although there were state laws against child labor, they were not enforced. The National Child Labor Committee and Lewis Hine sought to publicize the reality of child labor by taking images such as this one. Looking at this photograph, one wonders if this boy was just helping his family on weekends, the busiest market days, or if this was something he did during the week as well. (Courtesy of the Library of Congress, LC-DIG-nclc-04006.)

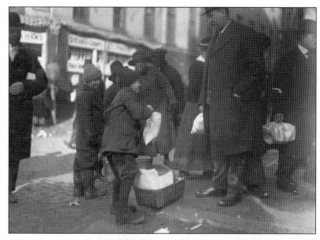

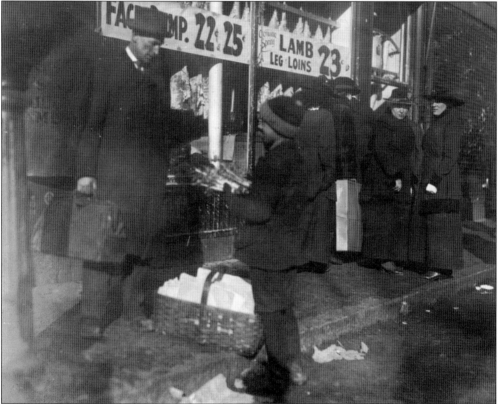

In the early 20th century, Boston was a major immigration center. Many of the immigrants and their children found work in Boston's market district. Often described as a documentary photographer, according to historian Alan Trachtenberg, Hine "performed his artistic labors within the institutional framework of Progressive Reform movements." The huge influx of immigrants led in part to increased urban population, poverty, and labor conflicts. The legal system was unresponsive to workers and exploited children at this time. In his evocative photographs, Lewis Hine sought to inform the public of the conditions brought on by industrial capitalism and "correct the system in the name of equality, justice, and progress." (Courtesy of the Library of Congress, LC-DIG-nclc-04001.)

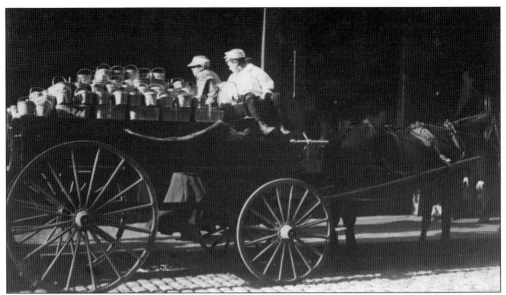

According to a 1904 *Boston Globe* article, the original vehicle used by peddlers was the handcart with its large wheels and solid body. "The bundles in front were joined together by a bar at the ends making a comfortable projection with which to either pull or push the cart." As the peddler became more prosperous, the handcart was set aside for a horse and wagon, an example of which can be seen in this October 1909 image. (Courtesy of the Library of Congress, LC-DIG-nclc-03325.)

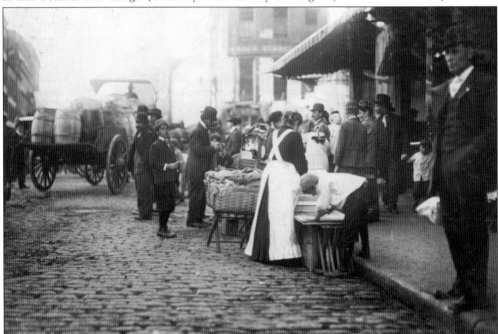

Boston's market district was frequented by people from all walks of life who came there daily to buy fresh meat, fish, or produce. This was a time when the icebox was the chief means of refrigeration, providing limited storage space as well as requiring regular deliveries of ice. In this October 1909 image, a maid, possibly from a Beacon Hill residence, is doing the daily shopping for the household. (Courtesy of the Library of Congress, LC-DIG-nclc-03335.)

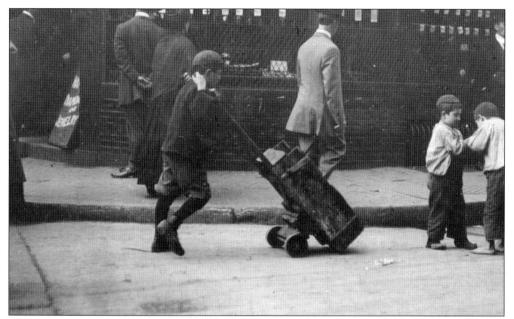

There were about two million children under 16 in the workforce at the time Lewis Hine took these photographs. Working for the National Child Labor Committee, Hine sought the enforcement of child-labor laws, which had been largely ignored by the states. The NCLC and Hine helped bring about stricter labor laws, giving youngsters their childhoods back. (Courtesy of the Trustees of the Boston Public Library.)

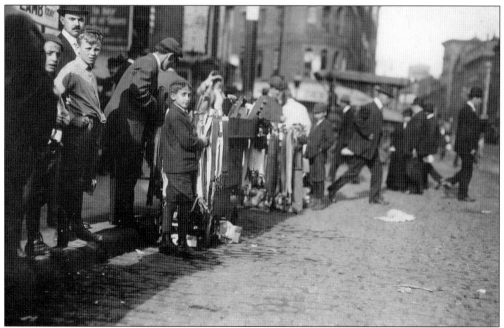

Children were employed not only to sell produce, but to peddle other wares within the market district. Children such as the boy shown in this 1909 image were forced to work long hours in all seasons. Often these children came from immigrant families who lived in crowded tenements. (Courtesy of the Trustees of the Boston Public Library.)

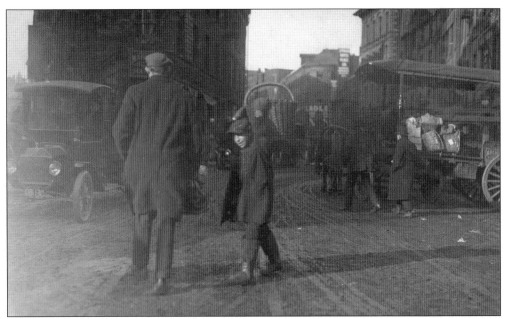

Lewis Hine titled this image *Lemon Boy*. He took it in the market district on January 27, 1917. A few years earlier, in 1914, the City of Boston, with the support of Mayor James Michael Curley, held meetings to extend the hours for outdoor shopping in the market district and create a "great white way" from Adams to Commercial Streets, including both North and South Market Streets for a Saturday night market. Although his plan was unrealized, Mayor Curley continued to lobby for open-air markets, including one in Haymarket Square, "believing that such markets will help in a measure to solve the high cost of living." (Courtesy of the Library of Congress, LC-DIG-nclc-04005.)

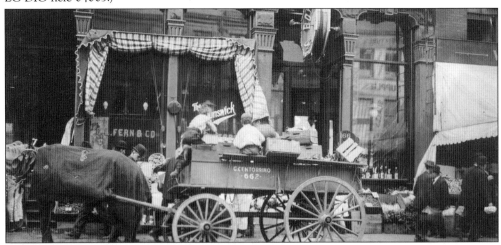

Beginning in May 1899, regulations were enacted in regard to peddlers. Any peddler selling in the public streets was required to register and was then issued a number. A May 25, 1899, *Boston Globe* article stated that "these numbers will be of such size and style to be easily read, and will be placed on the right hand side of the wagon and in a corresponding position on pushcarts and receptacles." Note the name and license number painted on the wagon. Giuseppe Centorrino of Boston was listed in the 1909 *Boston Directory* as a driver with a house at 21 Charter Street. He may have sold goods to supplement his job. (Courtesy of the Trustees of the Boston Public Library.)

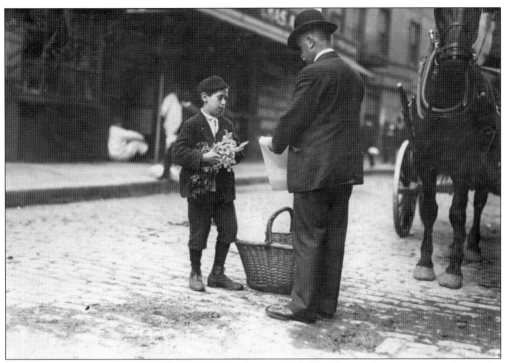

This photograph taken on January 27, 1917, depicts a child selling celery to a passerby in the market district. Lewis Hine traveled throughout the country photographing children at work. A National Child Labor Committee annual report noted that Hine took 800 photographs in one year alone. Using a new camera called a Graflex, Hine took these photographs, described as being "of great value in furnishing visual testimony in corroboration of evidence gathered in field investigation." (Courtesy of the Library of Congress, LC-DIG-nclc-03338.)

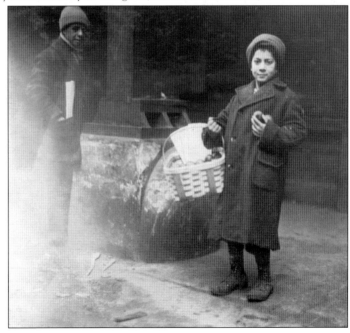

Lewis Hine captured a young boy selling produce from a basket in the market district on January 1917. The photographer referred to this type of image as a "human document." As a result of Hine and the National Child Labor Committee's efforts at documenting child labor, by 1912, Congress created a US Children's Bureau in the Department of Labor to investigate abuses of child labor. (Courtesy of the Library of Congress, LC-DIG-nclc-04003.)

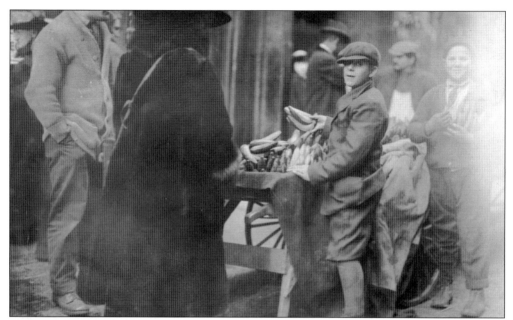

Two young boys sell bananas from a pushcart in the market district in January 1917. A 1904 article in the *Boston Globe* describes men working together on a percentage system to buy a single large load of 50 bunches of bananas. Since a small vendor could not afford this, he worked with a buyer who divided these bunches up into smaller lots among peddlers who then took them to the streets. When the returns were made, the buyer was paid a percentage on what sold in addition to what he received for the fruit itself. (Courtesy of the Library of Congress, LC-DIG-nclc-03999.)

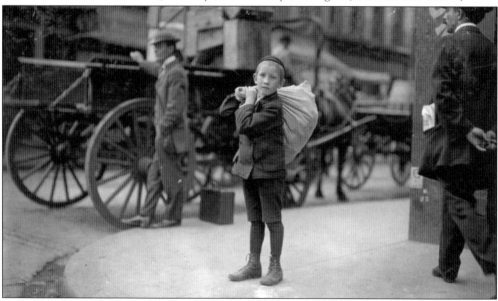

In October 1909, Lewis Hine photographed this boy carrying home refuse from the markets. Hine, a pioneer in making informal portraits of children at work, published his photographs in reformist periodicals like the *Survey* as well as on posters and bulletins for the National Child Labor Committee, bringing awareness of the evils of child labor. (Courtesy of the Library of Congress, LC-DIG-nclc-03343.)

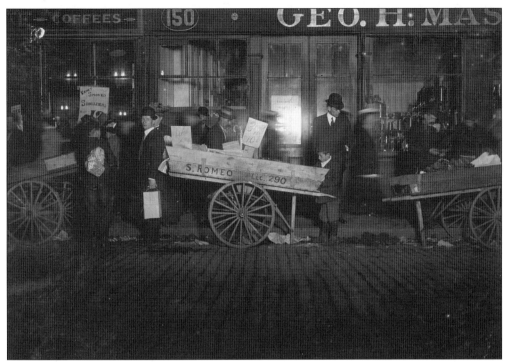

This night image was taken in October 1909 in front of the George H. Mason Company, which sold kitchen furnishings at 152 Blackstone Street. The S. Romeo whose name and license number appear on the pushcart may be Samuel Romeo, who was listed in the 1909 *Boston Directory* as a laborer living on Well Street. Boston "citizens" received even-numbered licenses; odd numbers went to "non-residents and persons who are not citizens." A 1904 *Boston Globe* article stated, "The Italians made the pushcart their own." (Courtesy of the Library of Congress, LC-DIG-nclc-03308.)

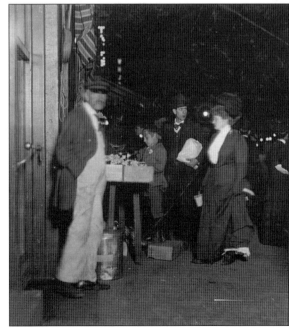

A young boy works at a sidewalk stand in the market district in October 1909. In 1908, strictly enforced laws allowed shop owners within a well-defined district to sell produce in front of their shops. A January 5, 1908, *Boston Globe* article told of the hardship brought to vendors outside this district by this new law. One owner whose fruit and vegetable shop in downtown Boston was in a basement and who for years displayed goods in boxes on the sidewalk complained that "people won't come down cellar to see our goods and we can't drag them down. They don't know what we've got to sell," and "business has fallen off one-half." (Courtesy of the Library of Congress, LC-DIG-nclc-03311.)

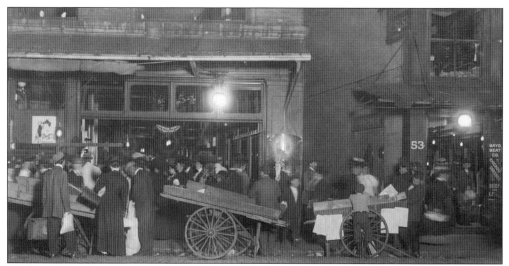

Between 700 and 800 vendors were selling their wares in Boston, with a concentration in the market district. Vendors were setting up on the sidewalks and in front of shops with a wide range of vehicles. This, along with pedestrians and shoppers, caused crowded sidewalks and traffic jams. The hours of operation for these vendors could be from early in the morning to late at night. In 1908, a law was enacted, setting the market time to be held from 5:00 p.m. to 11:00 p.m. Hine took this image at night in October 1909 in front of 53 North Market Street. The Mayo Meat Company, which sold wholesale beef, can be seen on the right. (Courtesy of the Library of Congress, LC-DIG-nclc-03307.)

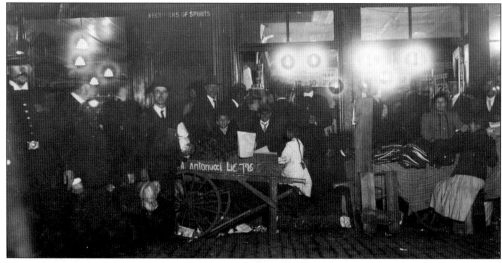

Hine photographed this night scene in front of Michael O'Keefe's grocery store at 148 Blackstone Street in 1909. A policeman can be seen on the far right. Newspaper accounts from the time report encounters between pushcart vendors and police over the vendors setting up and blocking sidewalks and causing traffic jams. In 1908, the police were charged with eliminating stands from downtown sidewalks and streets except for a well-defined area that allowed pushcarts and stands only on Blackstone Street from Haymarket Square to North Street, the north side of North Street from Blackstone to Union Street, the west side of Merchants Row from North Street to Faneuil Hall Square, the north side of North Market Street, and the north side of Faneuil Hall Square. (Courtesy of the Library of Congress, LC-DIG-nclc-03318.)

Four
1920–1950

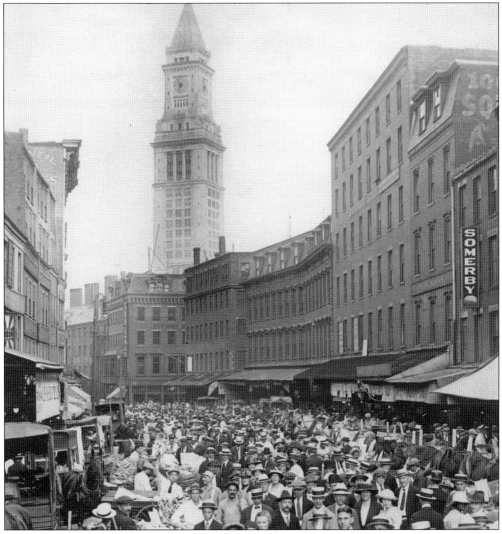

This view looking southeast down Blackstone Street toward North Street during market day was captured on July 26, 1921. Vendors with horse-drawn carts and wagons line the sides of the street while shoppers stroll down the block. The Custom House Tower is visible in the distance. The sign to the right advertises Somerby Provisions, which was located at 106 Blackstone Street. (Courtesy of the Bostonian Society.)

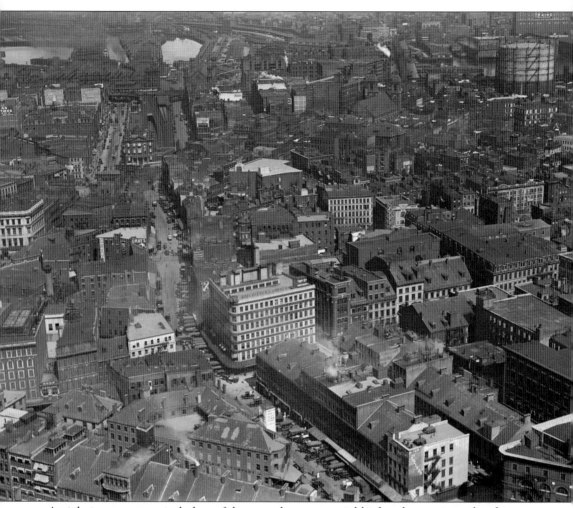

Aerial views are a particularly useful way to document neighborhoods, streets, and architecture at a particular time. This 1930s view by Leslie Jones shows Blackstone Street as it meanders toward the elevated railway, where North Station and the Boston Garden, now TD Garden, would eventually be located. Leslie Jones, a fixture of the Boston Press Corps, spent 39 years with the *Boston Herald Travelor*. His obituary in the *Boston Herald Travelor* in December 1967 described Jones as a "monument of photojournalism" who "always wore a gray tweed cloth cap. And a bright florid tie. He always insisted on using a large Graflex camera. And he only once approached the City Desk empty-handed." (Courtesy of the Trustees of the Boston Public Library, Leslie Jones Collection.)

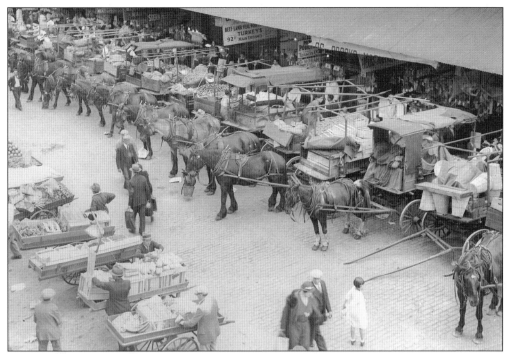

Horse-drawn carts were a popular means of transport in the market district in the 1930s. However, they were in danger of being barred by the city on Saturdays due to concerns by Humane Society officials that the horses were being mistreated by their owners and injured by the produce wagons they pulled. This 1930s image shows Blackstone Street toward North Street lined with produce vendors and customers selling and shopping among the horse-drawn carts. (Courtesy of the Bostonian Society.)

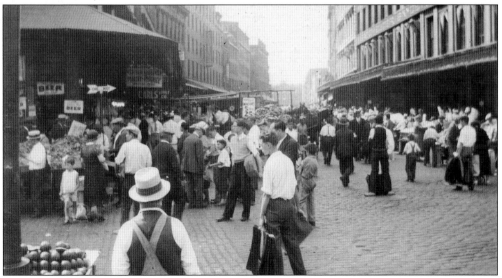

As this June 1933 image illustrates, the market district, here Blackstone Street toward Hanover Street, was a popular destination for thousands of last-minute shoppers who showed up just before closing time in search of a bargain. A October 1937 *Boston Globe* stated, "Customers come who know the ancient art of haggling over prices." (Courtesy of the Bostonian Society.)

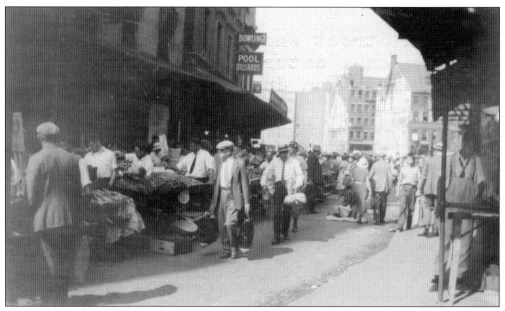

A view of North Street, between Merchants Row to the southwest and Blackstone Street to the northeast, captured on June 24, 1933, depicts pushcart vendors selling produce to men and women on the street. During this time, there were many conflicts between the horse-drawn carts and the pushcart vendors, who fought for prime selling space in the market district. (Courtesy of the Bostonian Society.)

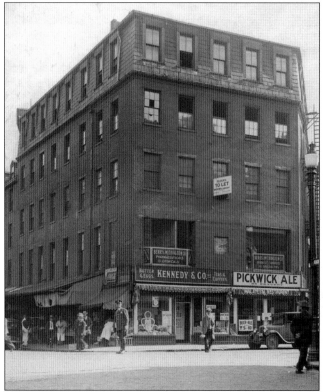

Francis X. Oberle owned the building located on the corner of 151 and 153 Hanover Street and 114–122 Blackstone Street at the time of this photograph. In business since 1876, Bostonia Cigar Company once sold hand-rolled cigars to customers. This view from 1935 shows the faded signage from the old factory and an active street level, with businesses selling commercial products in storefronts. (Courtesy of the Bostonian Society.)

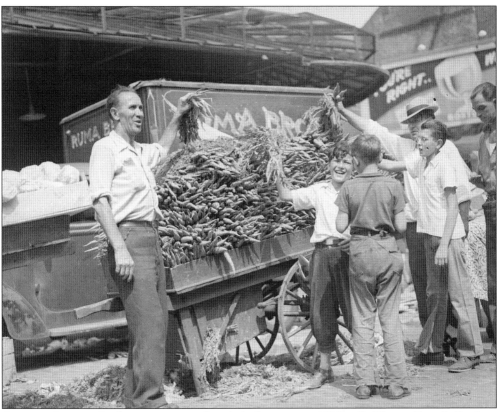

Giacamo Ruma, a Sicilian immigrant, founded a business in 1900 called Ruma Fruit & Produce and once owned his own pushcart at Haymarket. This photograph by Leslie Jones shows Giacamo selling carrots to enthusiastic young customers around 1935. He would arrive at 3:00 a.m. each morning to purchase his produce to sell later alongside the other meat, poultry, and produce vendors. (Courtesy of the Trustees of the Boston Public Library, Leslie Jones Collection.)

With the growing popularity of the automobile, many new rules for the market zone were drawn up by the city. The market district would be affected by the opening of the East Boston Tunnel on July 1, 1934. A man smoking a cigar sells "Sweet Pines" at 10¢ apiece from his stand in the market district about 1934. (Courtesy of the Trustees of the Boston Public Library, Leslie Jones Collection.)

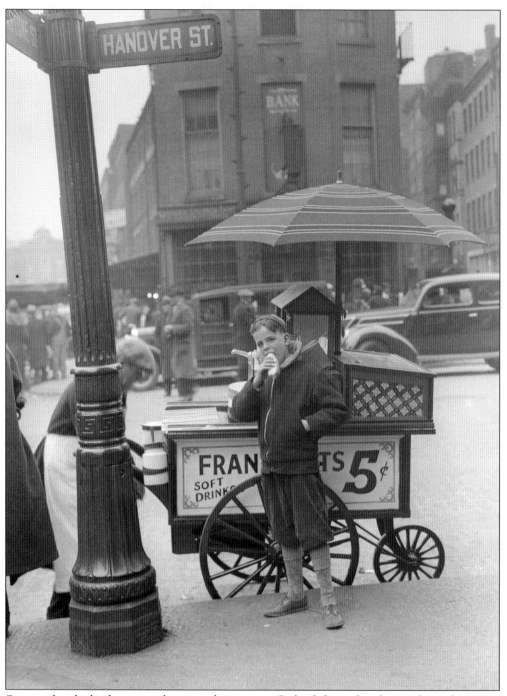

Sporting knickerbocker pants, this young boy enjoys a 5¢ frank from a hot dog vendor at the corner of Hanover and Blackstone Streets in 1937. Across the street is the Suffolk Savings Bank, which was then located on 158 Hanover Street. The view from this spot today is of the Rose Kennedy Greenway. (Courtesy of the Trustees of the Boston Public Library, Leslie Jones Collection.)

As the city grew, so too did the market centers. One thing remained a constant: Saturday bargain hunters seeking the best prices on produce. Blackstone Street provided a safe haven for pushcarts; elsewhere they may have been chased away by the police. Leslie Jones photographed this vendor bundling celery on his pushcart in 1937. (Courtesy of the Trustees of the Boston Public Library, Leslie Jones Collection.)

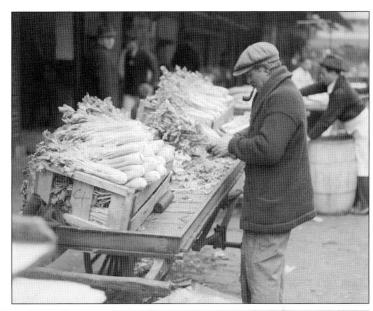

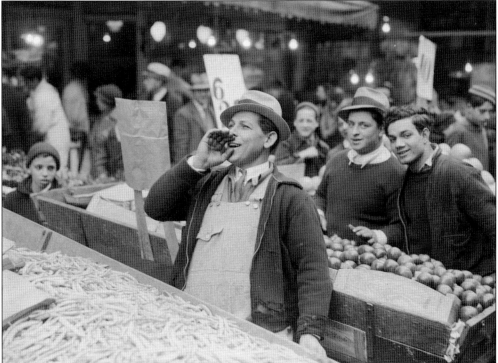

Many pushcart peddlers like this man seen here in this 1937 photograph were required by law to sell produce, meats, and fish from only 3:00 to 11:00 p.m. on Saturdays on North and Blackstone Streets and on Union Street to North Center Street. Though this was the case, many vendors disobeyed and would continue selling after 11:00 p.m. A *Boston Globe* article in January 1937 stated, "Pushcart peddlers play at hide and seek with policeman," and it was not uncommon to see the vendors running away from policemen when they were spotted. (Courtesy of the Trustees of the Boston Public Library, Leslie Jones Collection.)

Note the hanging light fixture in this 1937 image of Blackstone Street. The introduction of gas, and later electricity, made it easier for shops and peddlers to sell meats and produce late into the evenings. Gas lamps were introduced in the Faneuil Hall area as early as 1834, and the first electric lights in Boston were installed in Scolly Square. It would not be until 1913 that the city's last gas lamps were converted to electricity. (Courtesy of the Trustees of the Boston Public Library, Leslie Jones Collection.)

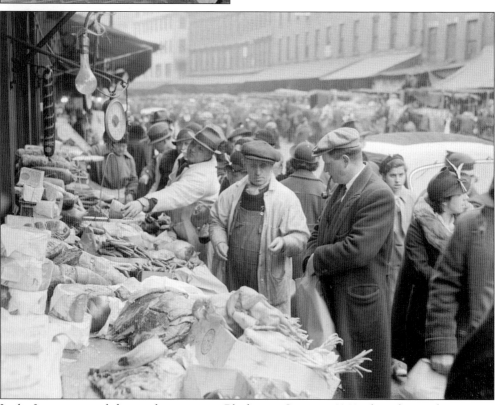

Leslie Jones captured this market scene on Blackstone Street in 1940 of vendors and customers buying and selling meat. An October 1937 *Boston Globe* article described a similar setting, stating it was "unchanging as an Old World scene." (Courtesy of the Trustees of the Boston Public Library, Leslie Jones Collection.)

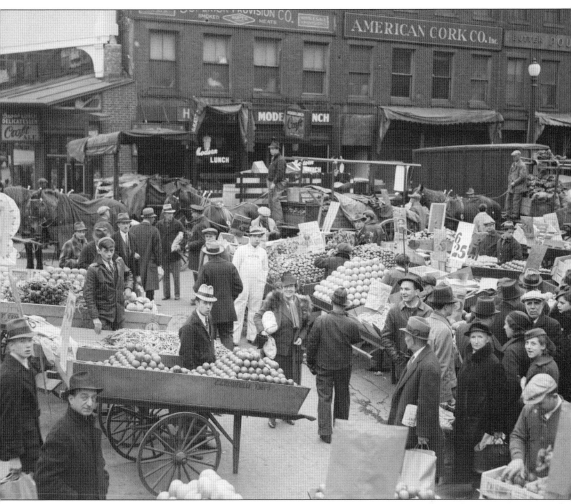

Pushcart peddlers would sell seasonal farm produce that came from far reaches of the United States. The most reliable year-round produce item was the banana. As seen in this Leslie Jones image from 1937, oranges in a box (lower right) marked "California Fruit Growers" were among the produce sold by this vendor on Blackstone Street. (Courtesy of the Trustees of the Boston Public Library, Leslie Jones Collection.)

The 1930s and the Great Depression were hard on Faneuil Hall, Faneuil Hall Market, and the surrounding area. Many shops and businesses in the market district closed and moved to other locations. A *Boston Globe* article from September 1932 discusses a decision by the Boston Market Gardeners Association "to seek a change in location as the result of growing congestion and a general need for additional space." The article goes onto report, "The growers say there are more modern places to display their wares." (Courtesy of the Trustees of the Boston Public Library, Leslie Jones Collection.)

In 1945, Haymarket Square had a bus terminal at the intersection of Blackstone and Cross Streets. In 1908, the subway ran streetcars that turned at Adams Square Loop and Brattle Loop at Scollay Square. This changed on January 26, 1967, when the Union and Friend platforms were renamed Haymarket. On May 10, 1971, the Massachusetts Bay Transportation Authority (MBTA) opened a new green line platform at Haymarket to the public. (Courtesy of the Bostonian Society.)

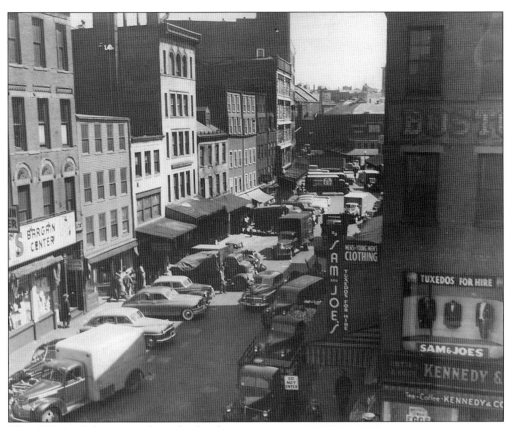

This 1949 weekday image shows both sides of Blackstone Street looking toward North Street from Hanover Street. The faded advertisement on top of Sam & Joe's Clothing Store is for the Bostonia Cigar Company and points to the variety of businesses found along Blackstone Street. Although the majority of the establishments sold meat, there were several restaurants catering to the lunchtime crowd, a tool and grinding company, two liquor shops, several produce sellers, and one macaroni manufactory. (Courtesy of the City of Boston Archives.)

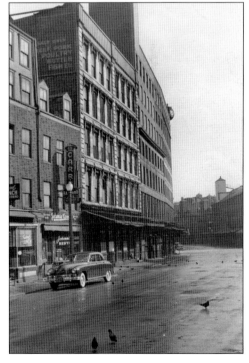

This early-morning image was taken in 1950 looking southeast from 85 Blackstone Street. The tall buildings and businesses like Johnnie Carr's restaurant and the Federal Lunch Restaurant (left) were torn down when a two-block stretch of buildings between Haymarket Square and North Street was demolished for the Central Artery construction. (Courtesy of the Bostonian Society.)

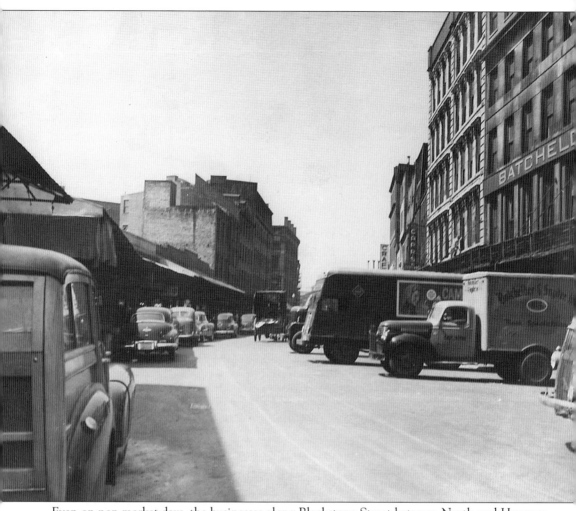

Even on non-market days, the businesses along Blackstone Street between North and Hanover Streets were busy, as evidenced by this photograph from 1945. In the 1940s, meat companies like the Batchelder and Synder Company, Inc., at 55 Blackstone Street dominated the business, lining both sides of the street. At that time, there were 51 businesses selling poultry and meat. (Courtesy of the City of Boston Archives.)

Five
1950s, 1960s, and the Arrival of the Central Artery

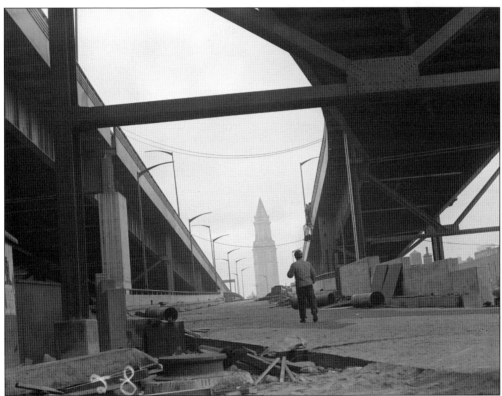

Construction began on the Central Artery in 1953, and the Causeway Street ramp officially opened in 1959. Interstate 93, US Route 1, and Route 3 were a combination of elevated and tunneled highways that navigated through the city. In this image taken by Leslie Jones, a construction worker walks up the ramp toward the elevated highway. The Custom House Tower is visible in the distance. (Courtesy of the Trustees of the Boston Public Library, Leslie Jones Collection.)

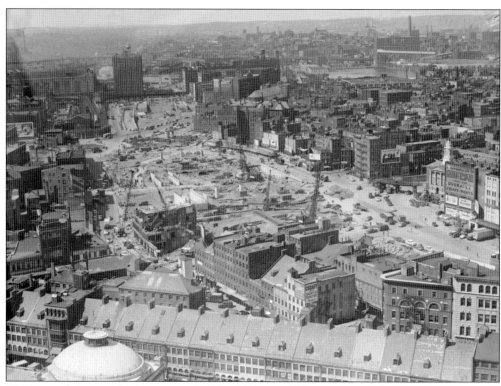

The Central Artery, also known as the John F. Fitzgerald Expressway and a part of Interstate 93, was a massive undertaking for Boston that was originally planned as early as the 1920s. Once construction began, there was opposition from residents over neighborhoods being divided. As time passed and more cars were in use, the traffic problem became an issue as well. Because of this, other projects, such as the Inner Belt Project, that were slated to complement the artery were quashed. In 2003, the Central Artery was demolished, after gradual closings of exit ramps rendered the artery barely functional. These two images by Leslie Jones taken about 1955 show the progression of the demolition of houses and businesses to make way for the Central Artery's construction in 1953. (Both, courtesy of the Trustees of the Boston Public Library, Leslie Jones Collection.)

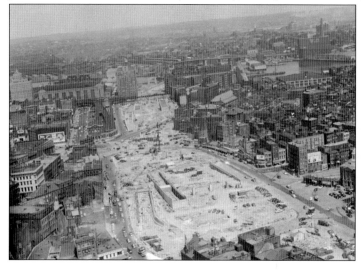

In 1948, the plan for the Central Artery, which sought to relieve Boston's traffic congestion, was popular among many residents but not with the pushcart vendors. The state began to seize properties by eminent domain for the project starting from the North End and moving south toward Chinatown during the early 1950s. City blocks vanished from the landscape to make way for the six-lane elevated highway. Financed through Massachusetts dedicated highway funds in 1953, the project cost $450 million. Haymarket and the pushcart workers had to constantly negotiate with city officials to keep the market open. A 1952 Boston Globe article notes, "The pushcart vendors protested vigorously. So did their friends and customers. Result: the pushcart men are still operating, although in a somewhat smaller area and almost under the shadow of the expressway." These images by Leslie Jones show the structural beginnings of the Central Artery (right) and the reduced Haymarket after destruction of one-half of Blackstone Street due to construction (below). (Both, courtesy of the Trustees of the Boston Public Library, Leslie Jones Collection.)

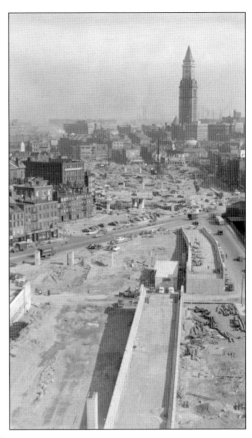

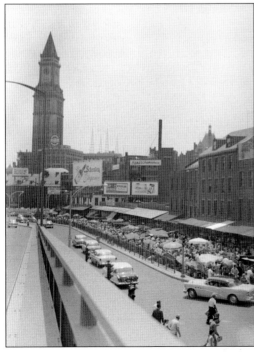

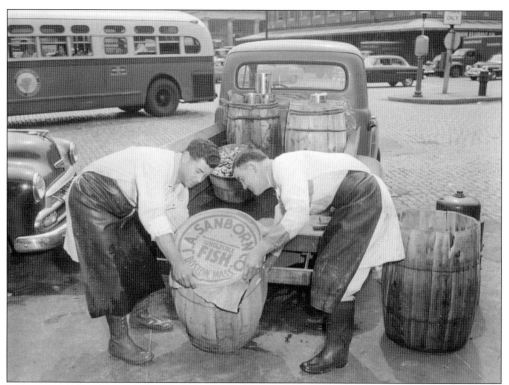

Photographer Leslie Jones in 1953 captured workers unloading fish in front of the J.A. Sanborn Company, a wholesale fish dealer. The company started in 1930 and was located at 6 Union Street until it moved in 1963 to 28 Merchants Row. At the top of both images one can make out Quincy Market on the left and Faneuil Hall on the right. This location is the area that in the 18th century was known as Fish Market. (Both, courtesy of the Trustees of the Boston Public Library, Leslie Jones Collection.)

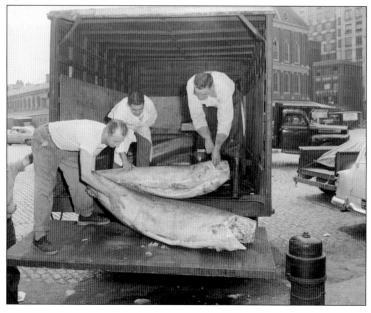

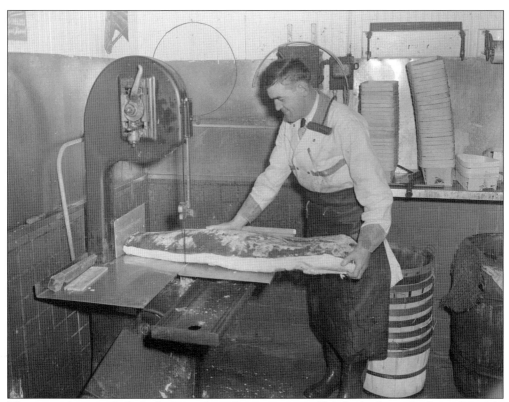

These two photographs by Leslie Jones show the preparation of fish for display at the front of the J.A. Sanborn Company. Charles Crones, owner, received a Best of Boston award for Best Fish Market in 1979. He said, "We go out of our way to buy the best, we buy whole fish off the boats, and cure them here. You can always find a good selection." Crones's business once supplied the Ritz-Carlton Hotel with "Sanborn Selections." The company survived a devastating fire that destroyed the building at 28 Merchants Row in November 1979. Charles Crones was determined to reopen the next day and said, "I still have my truck . . . so we can do the wholesale business but not the retail." (Both, courtesy of the Trustees of the Boston Public Library, Leslie Jones Collection.)

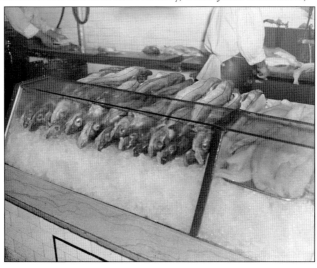

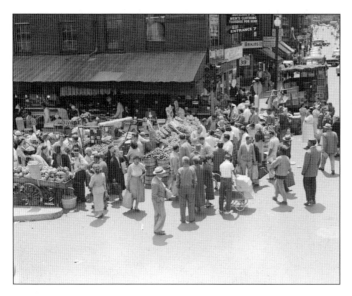

Despite the Central Artery construction and urban renewal, Haymarket remained a vibrant shopping destination for produce in 1956. The signage above the shoppers is a familiar sight: "Sam & Joe's Inc., Men's Clothing, Tuxedos for Hire." Sam and Joe's men's clothing store survived the upheaval, remaining in the same location that it was in before the construction. (Courtesy of the Trustees of the Boston Public Library, Leslie Jones Collection.)

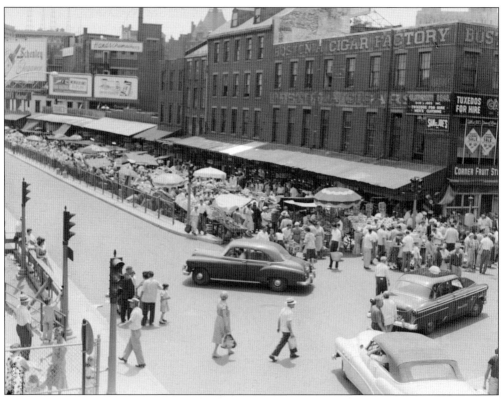

Crowds are present in this photograph of the corner of Blackstone and Hanover Streets, taken on June 29, 1956. Photographer Leslie Jones captured this view from the newly constructed Central Artery, which had an off-ramp at Haymarket. On Blackstone Street, the pushcart vendors and store owners go about their business as usual on a Friday or Saturday. (Courtesy of the Trustees of the Boston Public Library, Leslie Jones Collection.)

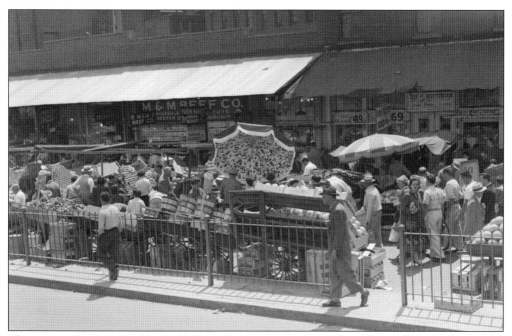

This image photographed by Leslie Jones features pushcarts and peddlers selling produce under the summer sun. Melons, oranges, apples, and zucchinis were popular seasonal items for sale at Haymarket, and the indoor businesses offered meats and seafood. (Courtesy of the Trustees of the Boston Public Library, Leslie Jones Collection.)

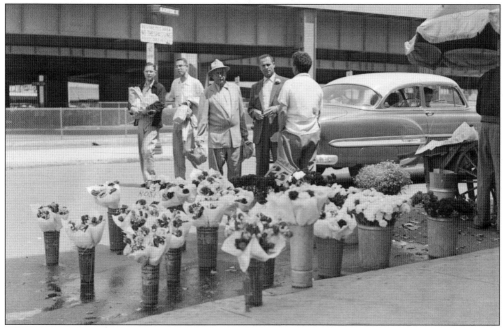

There have always been flower vendors at Haymarket. Leslie Jones photographed this one in 1956. Shoppers are strolling down Blackstone Street after a day at the market, likely carrying produce in brown bags. The Central Artery looms in the background, blocking a view of the North End. (Courtesy of the Trustees of the Boston Public Library, Leslie Jones Collection.)

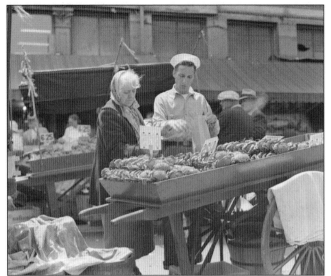

In a *Boston Globe* article from June 17, 1952, "The last unbearable straw, it's the last unbearable straw" uttered the pushcart vendors in reaction to the downsizing of the market district. Many of the 500 vendors left after the construction of the Central Artery, but some managed to survive. Many continued to sell goods, like this man offering live crabs on Blackstone Street, photographed by Leslie Jones in 1956. (Courtesy of the Trustees of the Boston Public Library, Leslie Jones Collection.)

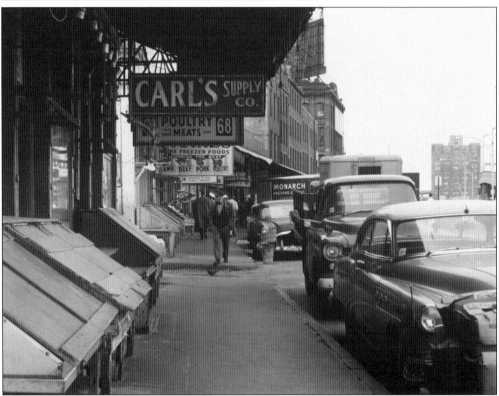

Between 1954 and 1959, MIT professor Kevin Lynch undertook a project called "The Perceptual Form of the City." It was a collaboration among researchers Gryörgy Kepes, Kevin Lynch, and photographer Nishan Bichajian. Their findings formed the basis for Lynch's theories on city planning discussed in his seminal work *The Image of the City*. The study focused on the cities of Boston, Los Angeles, and Jersey City, New Jersey. This image on Blackstone Street was one of several of the market district included in the study. (Photograph by Nishan Bichajian; courtesy of the Massachusetts Institute of Technology ©.)

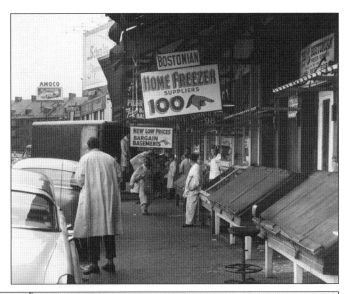

Nishan Bichajian, a professor of art and photography at MIT, took this weekday image in the mid-1950s of Blackstone Street showing the meat men unloading supplies. The wooden stands covering a portion of the sidewalk gave the vendors more space for selling and would be filled with goods on market days. (Photograph by Nishan Bichajian; courtesy of the Massachusetts Institute of Technology ©.)

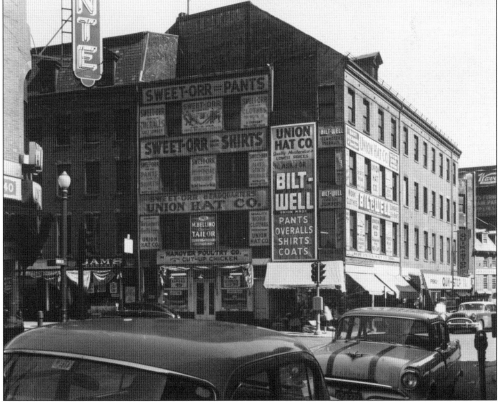

This photograph taken during the mid-1950s by Nishan Bichajian shows Hanover and Union Streets. The low building just visible to the right is the Union Oyster House. This image provides a glimpse of the advertisements of the era and shows the variety of businesses found within this corner of the Blackstone Block, among them a hat and clothing company, tailor, poultry company, food store, and restaurant. (Photograph by Nishan Bichajian; courtesy of the Massachusetts Institute of Technology ©.)

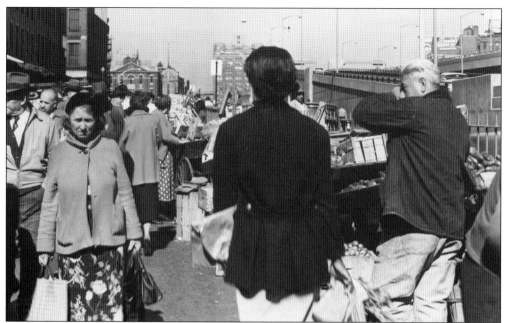

Shoppers and vendors fill this image of Blackstone Street taken in the 1950s. The Central Artery can be seen at the top right, and in the far distance at the end of Blackstone Street is Haymarket Square. The low building with the triangular pediment, on the left located within the square, was the Boston City Hospital Relief Station, which served the West End and the North End. (Photograph by Nishan Bichajian; courtesy of the Massachusetts Institute of Technology ©.)

This image is of the C & C Thrift Shop, selling baked goods at 100 Blackstone Street. The shop was here for one year only, 1970. There were at least six vacant shops along Blackstone Street at this time. During the late 1960s and early 1970s, many shops came and went. Others like the Pilgrim Market were there for years, and some like the Puritan Beef Company and Harry's Cheese and Cold Cut Center remain to this day. (Courtesy of Boston City Archives.)

Haymarket changed drastically in the 1950s, so too did the types of produce offered to customers and the ways they were transported to the market. The transportation of goods shifted from railways to trucks and barges. The Central Artery dominates the frame with an advertisement above for Red Cap Ale. (Photograph by Nishan Bichajian; courtesy of the Massachusetts Institute of Technology ©.)

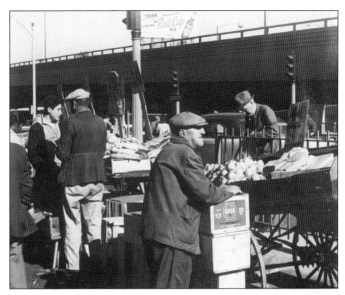

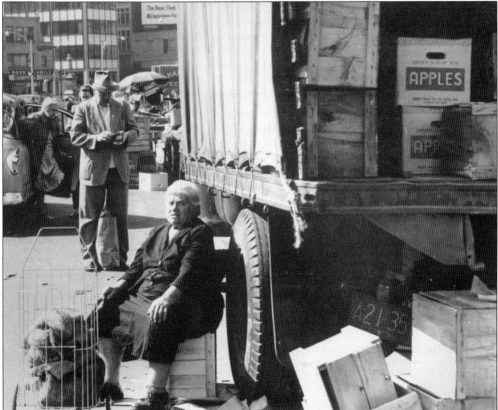

In the 1950s when this photograph was taken, many of the vendors, workers, and shoppers of Haymarket were of Italian descent and lived in the North End. According to historian Alex R. Goldfield, the construction of the Central Artery "took a huge toll on the people of the North End" with many people losing their homes and livelihoods while others endured years of disorder. (Photograph by Nishan Bichajian; courtesy of the Massachusetts Institute of Technology ©.)

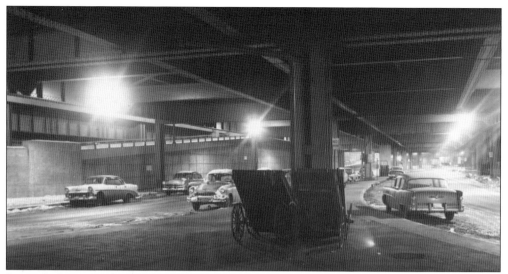

Beneath the Central Artery, this quiet scene depicts old pushcarts and parked cars on a quiet winter night. Parking cars during the 1950s posed huge issues for the city, as the space beneath the expressway had few signs and no parking meters, causing congestion and safety issues. In a *Boston Globe* article published in 1958, Edwin Crowley commented about pedestrian safety: "Anyone who thinks they can force the public to use those underpasses is crazy, why, women won't go through them unless accompanied by armed guards." (Photograph by Nishan Bichajian; courtesy of the Massachusetts Institute of Technology ©.)

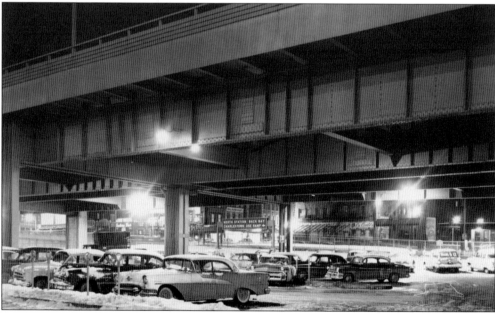

Hanover Street and the edge of the North End are visible in this photograph, likely taken toward the end of the 1950s by Nishan Bichajian. This parking lot would likely have been used by restaurant goers in the North End and visitors to Haymarket Square. A sign that reads "North Station Back Bay Charlestown Use Ramp" was likely taken down during the Big Dig, when the city demolished the Central Artery. (Photograph by Nishan Bichajian; courtesy of the Massachusetts Institute of Technology ©.)

Photographer Robert Severy is a well-known Boston historian. Severy has explored the streets of Boston ever since he could hold a camera, capturing thousands of scenes of the city through many pivotal and transitional times. These images taken on Blackstone Street illustrate the street during the day, a quiet scene of the buildings and cars. In 1963, Peter Manoli, a lawyer for the City of Boston, became the owner of Pete's Pub on Blackstone Street, as shown in the image below. Manoli also owned the John Hawes Tavern on Change Place in downtown Boston and was an active member of the Order of the Sons of Italy in America. (Both, courtesy of the Bostonian Society.)

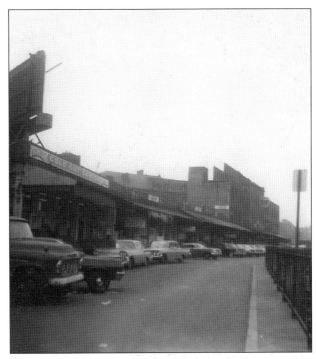

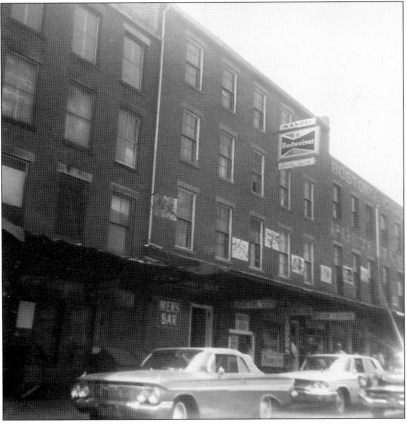

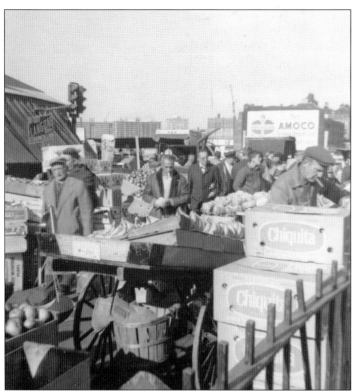

In this photograph by Robert Severy, pushcarts clutter a busy Blackstone Street on market day. Just off to the left, a small sign reading "Re-Elect Langone City Councilor" is visible. Frederick C. Langone was seeking election to his second term on the city council. A longtime supporter of Haymarket, he served as the city council president in 1961 and again from 1964 to 1983. (Courtesy of the Bostonian Society.)

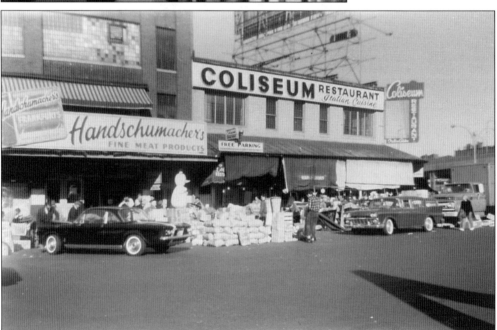

The Coliseum Restaurant, located at the corner of North and Blackstone Streets, served Italian cuisine to the neighboring community. Haymarket vendors still wrap around this block today selling seasonal produce and flowers. The Coliseum was replaced by the Millennium Bostonian Hotel. (Courtesy of the Bostonian Society.)

These two photographs taken by Robert Severy show North Street about 1962 looking toward the Central Artery in the distance. In 1962, meat cutters and packers were involved in a dispute with 24 packinghouses and threatened a strike. The price of meat in many stores went up, probably because the dealers had gone outside of Boston to make purchases. The union, which represented the meat cutters, was seeking a $2.25 raise, a guaranteed 40-hour work week, and a three-year contract. The buildings and businesses seen here no longer exist. Markets and pushcart vendors have since been confined to a smaller area wrapping around Blackstone Street. (Both, courtesy of the Bostonian Society.)

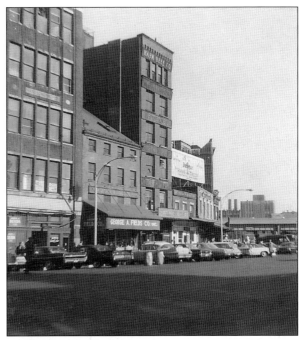

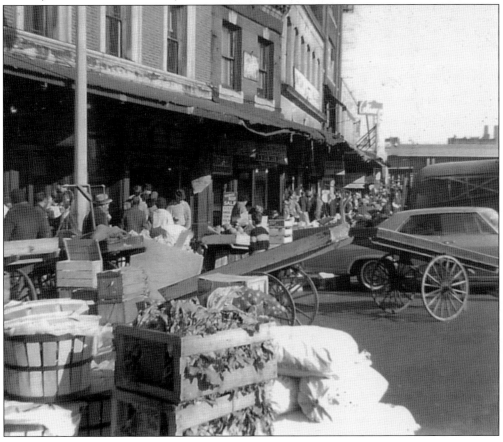

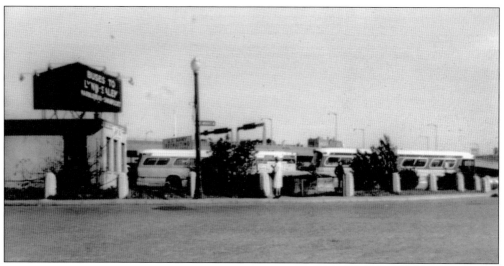

In the 1960s, when Robert Severy took these photographs, Haymarket Square was still a transportation hub. The above image shows the Eastern Massachusetts Street Railway Station. The company, known as the Eastern Mass, originally operated streetcars and later buses. The Eastern Mass was taken over by the Metropolitan Transit Authority (MTA). In turn, the MTA was succeeded by the MBTA in August 1964, which sought to enlarge the area of bus service. The Eastern Mass station is also seen in the photograph below, in the center of the square. The low building behind the bus station is the Boston City Hospital Relief Station. This image shows the results of urban renewal in the West End with the remains of demolished buildings and new construction. (Both, courtesy Bostonian Society.)

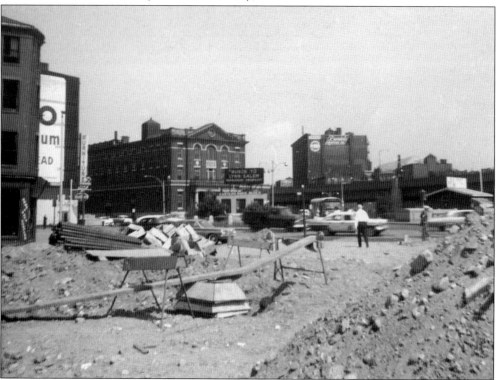

Six
WENDY SNYDER MACNEIL'S MOMENT IN TIME, 1968–1969

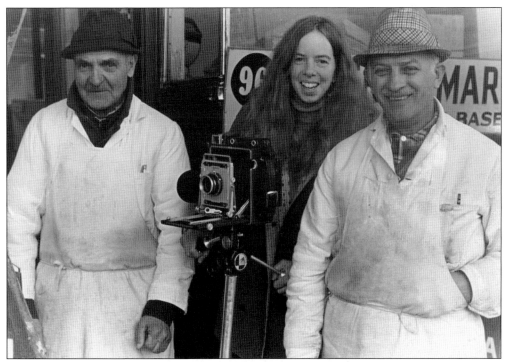

Wendy Snyder MacNeil, pictured here between two Haymarket butchers, was a photographer before becoming a filmmaker in 1990. In 1970, she published *Haymarket*, a book showcasing her extraordinary images and interviews with the market men. Her photographs are in many collections, including the Museum of Modern Art and the Metropolitan Museum in New York. All the photographs in this chapter were taken by Wendy Snyder MacNeil between 1968 and 1969. (Courtesy of the Wendy Snyder MacNeil Archive, Ryerson Image Centre, Toronto, Canada, © Wendy Snyder MacNeil.)

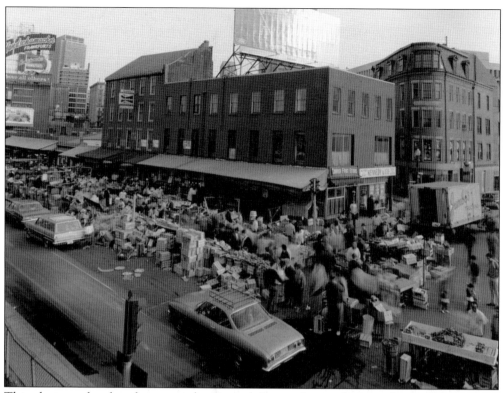

This photograph taken from atop the Central Artery shows a busy market at the corner of Blackstone and Hanover Streets. The three-story building at the center of the image originally had five stories. The top two stories were removed to reduce the tax assessment during the economic depression of the 1930s. As the economy improved, later in the century, the top two stories would be replaced. Kennedy and Company, specializing in butter and eggs, was located in the building as far back as the early 1930s. (Courtesy of the Wendy Snyder MacNeil Archive, Ryerson Image Centre, Toronto, Canada, © Wendy Snyder MacNeil.)

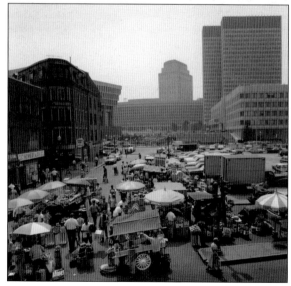

This image was taken from the Central Artery looking down Hanover Street at midday with the nearly complete Government Center in the background. Work was still continuing on the City Hall Plaza. After the block of Blackstone Street between North and New Sudbury Streets was demolished, part of the resulting vacant area was used as a parking lot for city employees (right). The city made the parking spaces available on Saturday to the vendors and shoppers. (Courtesy of the Wendy Snyder MacNeil Archive, Ryerson Image Centre, Toronto, Canada, © Wendy Snyder MacNeil.)

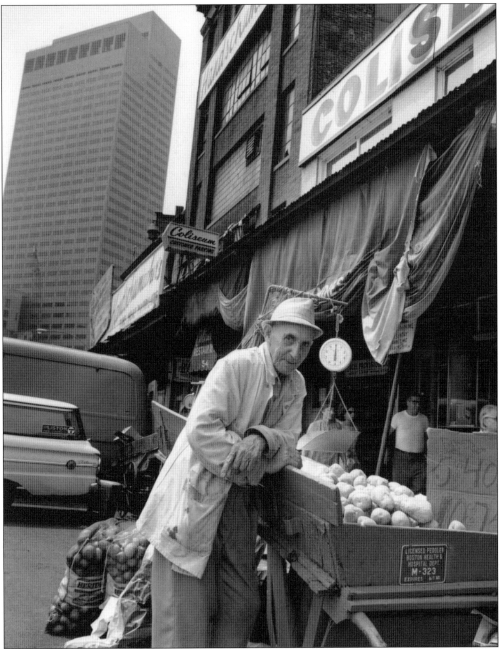

Wendy Snyder MacNeil captured "Professor" Isadore Edelstein with his pushcart (note the vendor license on his cart) in front of the Coliseum Restaurant at the corner of Blackstone and North Streets. She remembers that people at the market called him "Professor" because "when we made 3-4 dollars a week, . . . the Professor made 10." It seems like everyone at the market had a nickname, for example, Joe Bagman, Joe Bananas, Joe the Grape, Joe Tomato, Johnny Tomato, Pauly Peppers, and so forth, a practice that continues to this day. (Courtesy of the Wendy Snyder MacNeil Archive, Ryerson Image Centre, Toronto, Canada, © Wendy Snyder MacNeil.)

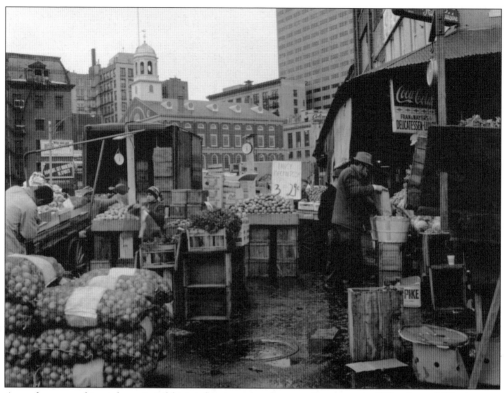

A pushcart and stands are visible in this image taken at the corner of North and Blackstone Streets. At this time, peddlers paid an annual fee of $12 for a license and were assigned a certain spot. This had not always been the case. Not too long before this photograph was taken, vendors with their pushcarts would line up by Faneuil Hall and wait for a policeman to blow a whistle signaling that they could now claim a spot. "Predictably that method caused wild fights and near riots," state *Boston Globe* on December 6, 1969. (Courtesy of the Wendy Snyder MacNeil Archive, Ryerson Image Centre, Toronto, Canada, © Wendy Snyder MacNeil.)

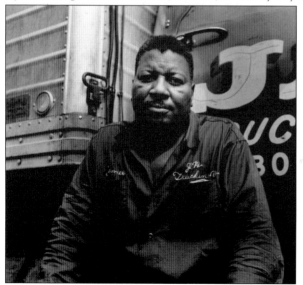

Market workers included not just the vendors and their assistants, but also the truckers hired to deliver the produce. Truckers like James, pictured here, played a key role in the way the market operated. They collected the produce at the New England Produce Center in Chelsea, brought it to Haymarket, unloaded it, and at the end of the day reloaded whatever produce would keep until the following week onto the truck and took it to storage facilities. (Courtesy of the Wendy Snyder MacNeil Archive, Ryerson Image Centre, Toronto, Canada, © Wendy Snyder MacNeil.)

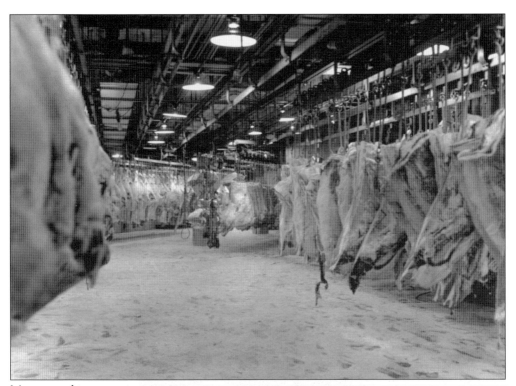

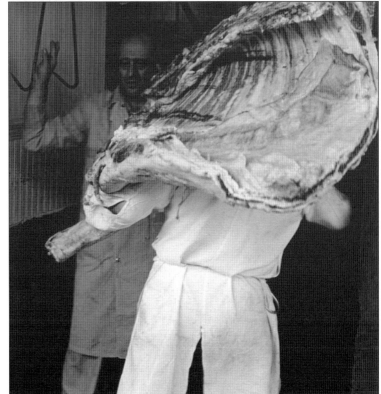

Meat was a big business. When these photographs were taken, there were between 14 and 17 meat vendors in the shops along Blackstone Street and another 11 to 12 along North Street between Union and Blackstone Streets. The meat vendors did the majority of their business when the market ran on Fridays and Saturdays. (Courtesy of the Wendy Snyder MacNeil Archive, Ryerson Image Centre, Toronto, Canada, © Wendy Snyder MacNeil.)

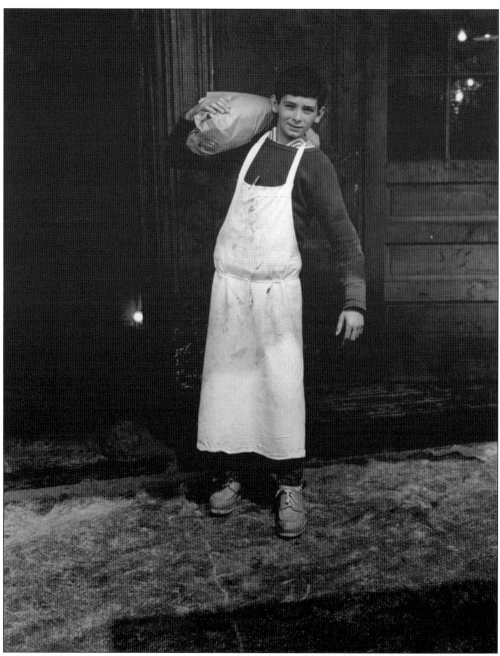

Here, MacNeil captured a young meat man, Nino Bertolino. At the time, MacNeil noted, "Most of the marketmen are second-generation immigrants, some still living in the North End, some are forced to move to Brockton, Chelsea, Dorchester, or Somerville after the West End was so ruthlessly renovated. Fathers and grandfathers of marketmen emigrated from Italy, Sicily, Greece, Ireland, and other European countries. Irish, Italians, Negroes, and Jews work side by side, openly chiding one another about their differences." (Courtesy of the Wendy Snyder MacNeil Archive, Ryerson Image Centre, Toronto, Canada, © Wendy Snyder MacNeil.)

In her book *Haymarket*, Wendy Snyder MacNeil quoted an unidentified interviewee: "Around 11:00 o'clock at night when they all left, they would dump what they had left on the street and you could see these people come down with empty onion bags and pick up and go through all these vegetables and put 'em in the bags . . . And you couldn't believe that in this country something like that would happen." (Courtesy of the Wendy Snyder MacNeil Archive, Ryerson Image Centre, Toronto, Canada, © Wendy Snyder MacNeil.)

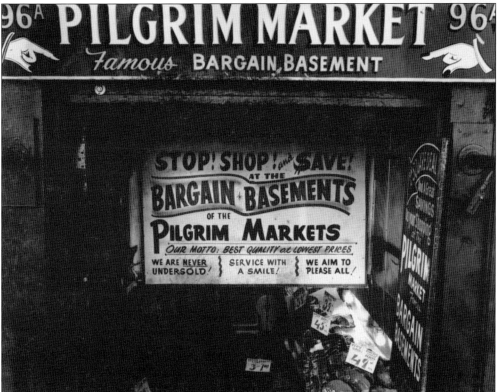

Pilgrim Market, located in the basement at 94A Blackstone Street, did a brisk business until the state health department closed it down in the 1970s. Then, as now, federal and state inspectors patrolled the market. MacNeil wrote that the inspectors could be seen "making peddlers throw produce that is 'decayed too bad' on the dump truck which is on Blackstone Street all weekend, and are often engaged in spirited discussions with the meat men in the inner recesses of their freezers." (Courtesy of the Wendy Snyder MacNeil Archive, Ryerson Image Centre, Toronto, Canada, © Wendy Snyder MacNeil.)

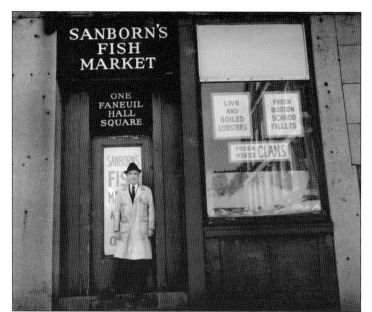

For many years, North Street was home to many fish markets. By the late 1960s, almost all were gone. Here, Charles Crones stands in front of his shop, Sanborn's Fish Market, one of the last fish markets to survive. (Courtesy of the Wendy Snyder MacNeil Archive, Ryerson Image Centre, Toronto, Canada, © Wendy Snyder MacNeil.)

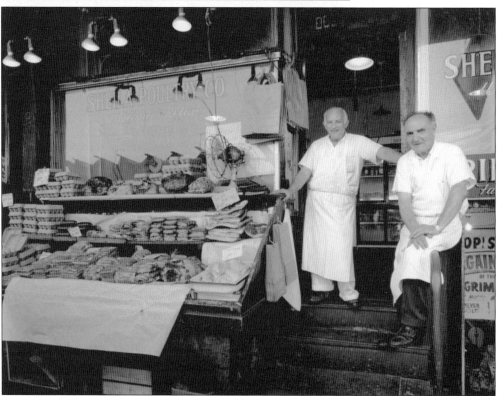

In her book *Haymarket*, Wendy Snyder MacNeil attempted "to document the relationship between the people of the market and their environment." She certainly succeeds with this photograph of Max Bonstein (left) and Ike Lerner (right) standing in front of the Sheila Poultry Company at 96 Blackstone Street. (Courtesy of the Wendy Snyder MacNeil Archive, Ryerson Image Centre, Toronto, Canada, © Wendy Snyder MacNeil.)

Restaurants and cafés played, and continue to play, an important role in the market. During the week they catered more to the office workers from nearby Government Center and downtown. However, they were often at their busiest during market days serving tourists, shoppers, and the vendors. (Courtesy of the Wendy Snyder MacNeil Archive, Ryerson Image Centre, Toronto, Canada, © Wendy Snyder MacNeil.)

This unpublished photograph by MacNeil illustrates how in the late 1960s the produce was seasonal, which is not the case today. Non-local fruit and vegetables came mainly from the South and California. (Courtesy of the Wendy Snyder MacNeil Archive, Ryerson Image Centre, Toronto, Canada, © Wendy Snyder MacNeil.)

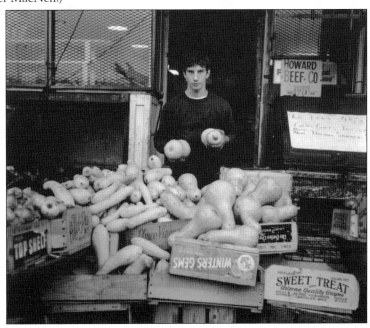

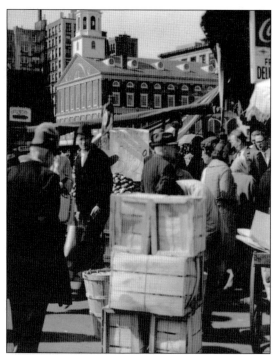

One market worker interviewed by MacNeil summed up the difference between customers on Friday and Saturday. On Friday "they come down, they buy, they don't quibble about prices, they'll get better merchandise, and it's fresher. Saturday there's less business, more aggravation, people come looking for bargains." (Courtesy of the Wendy Snyder MacNeil Archive, Ryerson Image Centre, Toronto, Canada, © Wendy Snyder MacNeil.)

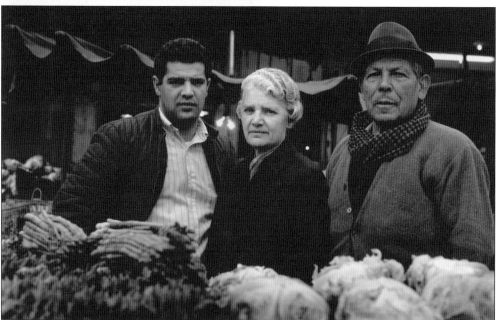

Gus Serra is seen here with his mother, Anna, and his father, Manny. Gus has been involved with the market since he was six or seven. He remembers "going down with his father, who sold string beans and tomatoes off a pushcart." His family lived in Boston's West End, and his grandparents were the first members of the family to work at Haymarket. Remembering his mother, Gus noted, "She'll outsell anyone down here normally. Customers will come by and ask solely for her." (Courtesy of the Wendy Snyder MacNeil Archive, Ryerson Image Centre, Toronto, Canada, © Wendy Snyder MacNeil.)

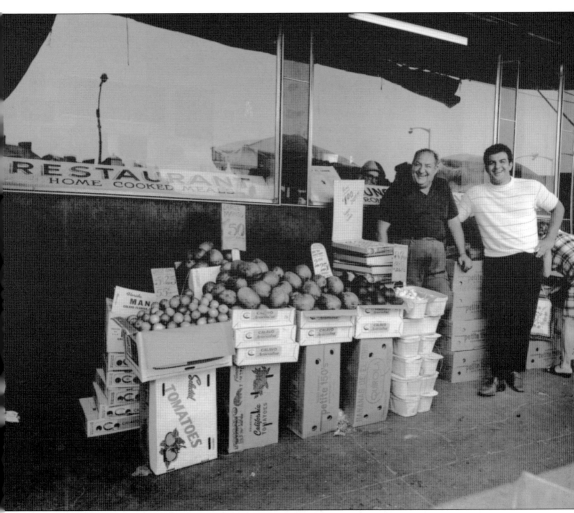

Wendy Snyder MacNeil photographed Salvature "Tudi" Fisichella and his son Frank at their stand at the corner of North and Blackstone Streets. At this time, Tudi had worked at the market for 45 years, and his father had worked at the market for 30 years. Frank was just out of the military. He began working at the market when he was nine or 10 years old, and he can still be found working at the same spot at Haymarket today. (Courtesy of the Wendy Snyder MacNeil Archive, Ryerson Image Centre, Toronto, Canada, © Wendy Snyder MacNeil.)

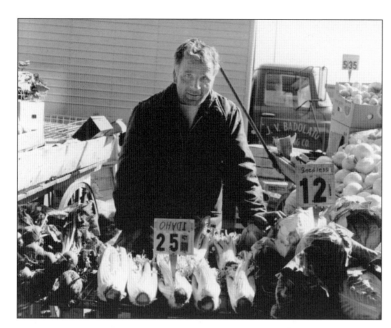

Pat Pennacchio was one of a family of 10. He and his brother Frank, also a market worker, grew up on North Margin Street in the North End. Pat spent most of his life working at Haymarket. (Courtesy of the Wendy Snyder MacNeil Archive, Ryerson Image Centre, Toronto, Canada, © Wendy Snyder MacNeil.)

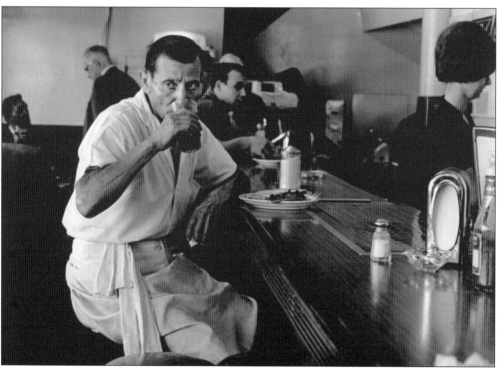

Here, Joe Bertolino takes a break at one of the cafés in the Blackstone Block. Two of the better-known restaurants at Haymarket were Fran and Mayer's Delicatessen at 60 North Street and the larger Coliseum Restaurant at 54 North Street, which served breakfast and lunch downstairs with dinner service and a bar above. (Courtesy of the Wendy Snyder MacNeil Archive, Ryerson Image Centre, Toronto, Canada, © Wendy Snyder MacNeil.)

The market was completely closed down on a late Friday evening with not a person to be seen, but come dawn the market would be back in full swing. One vendor commented, "Saturdays the merchandise has been outside for two days and if it's going to show any problems, it'll show on Saturday. We'll give it out Saturday night at ridiculously low prices." (Courtesy of the Wendy Snyder MacNeil Archive, Ryerson Image Centre, Toronto, Canada, © Wendy Snyder MacNeil.)

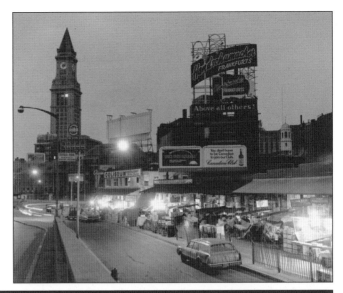

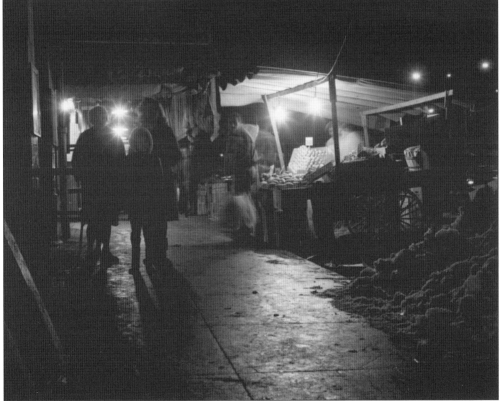

The market generally was open late into the evening, although the crowd, particularly in cold weather, thinned out after 7:30 p.m. A *Boston Globe* article from December 1969 describes the harsh conditions endured by the peddlers in winter and tells how they would typically "put up canvas and plastic sheets to break the cold wind and burned wooden crates in big ash barrels." (Courtesy of the Wendy Snyder MacNeil Archive, Ryerson Image Centre, Toronto, Canada, © Wendy Snyder MacNeil.)

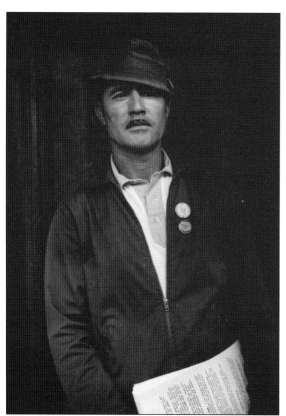

Wendy Snyder MacNeil took this photograph at Haymarket and labelled it "California grape boycotter." In the late 1960s, there was a nationwide boycott of California grapes organized by the striking United Farm Workers Organizing Committee to protest working conditions and pay. A 1968 *Boston Globe* article tells the story of Marcos Munoz, a striking grape picker who came to Boston for work. Leaving his wife and children in California, Munoz describes what life was like as a picker. "We average $5.00 to $6.00 a day (when working) with very poor living conditions. And with a 10 month season we can earn only $2,000.00 a year at most." Protesters in support of the boycott were not only at Haymarket, but also marched to the Chelsea Produce Center on May 30, 1968. (Left, courtesy of the Wendy Snyder MacNeil Archive, Ryerson Image Centre, Toronto, Canada, © Wendy Snyder MacNeil; below, courtesy of the Walter P. Reuther Library, Wayne State University.)

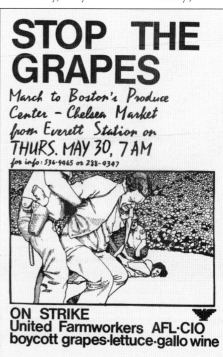

Seven
1969 TO THE BIG DIG

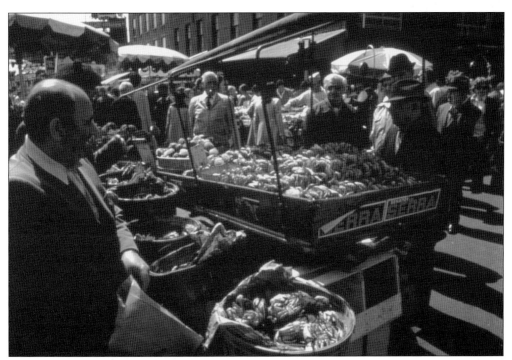

In 1971, the Environmental Protection Agency (EPA) sponsored Documerica, a project that hired freelance photographers to capture images of life in the 1970s and environmental issues across the United States. The project helped the EPA create a map identifying specific environmental problems or issues. Besides Haymarket, the project also documented the noise pollution crisis in the Neptune Road neighborhood adjacent to Logan Airport's main runway in East Boston. (Courtesy of the National Archives 412-DA-7579.)

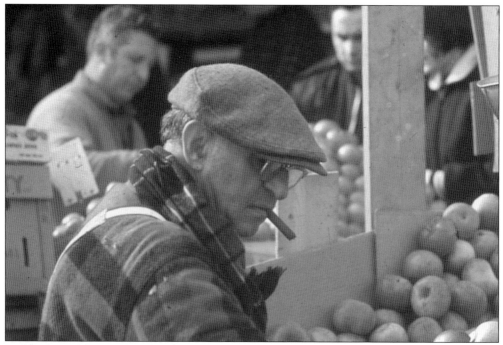

In the summer of 1969, Peter H. Dreyer, a recent immigrant from Germany working in advertising and commercial photography, captured this portrait of a peddler. As a hobby, Dreyer photographed many scenes in Boston. The market was in transition at this time, and the pushcarts were going the way of the horse and horse-drawn wagon. Gus Serra remembers, "Well, carts became sort of obsolete . . . But eventually they became pallets, with pallets on top of them, with pallets on the floor, with cardboard on it to protect your feet and what not. I would say that all started to change in the seventies." (Courtesy of Peter H. Dreyer and the Boston City Archives.)

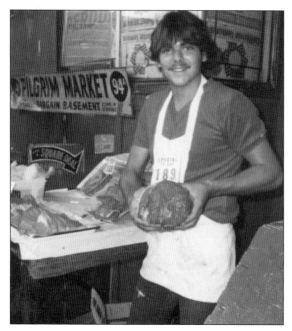

Teenager Jesse Holler, seen here in 1978, worked a stand at Haymarket and occasionally helped out at the Pilgrim Market on Blackstone Street. Later, he had a coffee shop at the market. He remembers, "I made breakfast, subs, coffee, and I opened on Friday and Saturday. So I did that like in my, like seventeen, eighteen, nineteen years old. And then I started to work for this other guy down Haymarket . . . he had a spot at Downtown Crossing, when Downtown Crossing just began. So I was there for about four or five years. I opened up a fruit store in Gloucester. And I did that for about five or six years . . . And then the day I closed the store, the following weekend I was right back down Haymarket, right in my old spot." (Courtesy of Jesse Holler.)

Peddler Dominico Serra, father of Gus Serra, is selling his produce in this 1970s photograph. In a *Boston Globe* article dated November 23, 1974, Gus, at the time the president of the Haymarket Pushcart Association, said, "My father worked his butt off to send me to college." Gus, 29 at the time, fought hard for the peddlers: "They're trying to protect themselves from any city or state agency or private business that may be looking to remove them or change what they have and what their fathers and grandfathers before them have established." (Courtesy of Emanuel Gus Serra.)

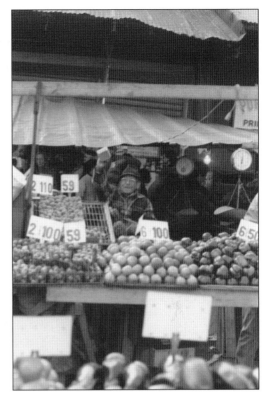

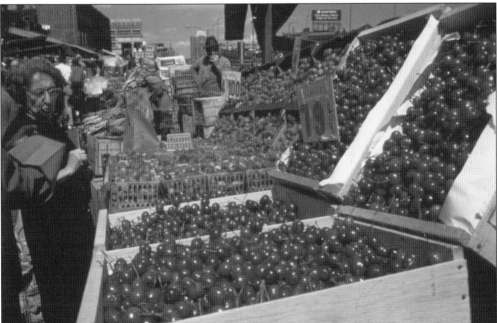

Ernst Halberstadt, a muralist for the Works Progress Administration (WPA) before becoming a part of the Documerica project in Boston, took this photograph in May 1973. Halberstadt and other photographers made 15,000 images as part of the Documerica project depicting cities across the country. (Courtesy of the National Archives, 412-DA-7543.)

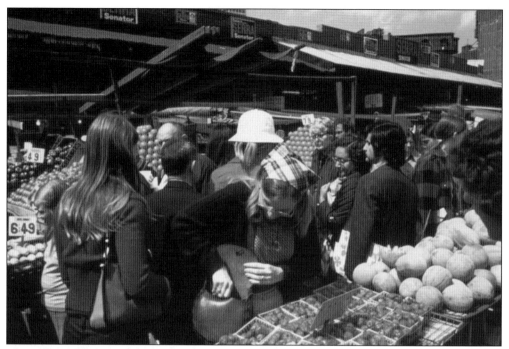

This image by Ernst Halberstadt, taken in May 1973 as part of the Documerica project, illustrates just how busy Haymarket and Blackstone Street could be on a warm spring day. Blackstone Street was often cramped and packed full of vendors on each side of the street. (Courtesy of the National Archives, 412-DA-7556.)

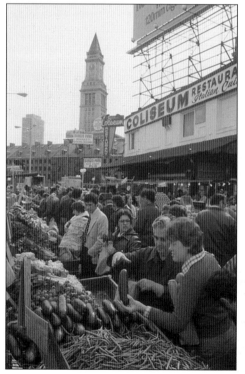

In the 1970s, the more than 200 fish and produce vendors faced tough regulations from city officials. One proposed regulation gave preference to residents of Boston for pushcart licenses. Another imposed a lottery system if there were too many applicants for pushcarts. These kinds of issues were commonplace for the market during this time. These particular regulations were often debated between Joseph Matera, president of the Haymarket Pushcart Association; Mayor Kevin White; and Stephen Dunleavy, public safety advisor. (Courtesy of Peter H. Dreyer and City of Boston Archives.)

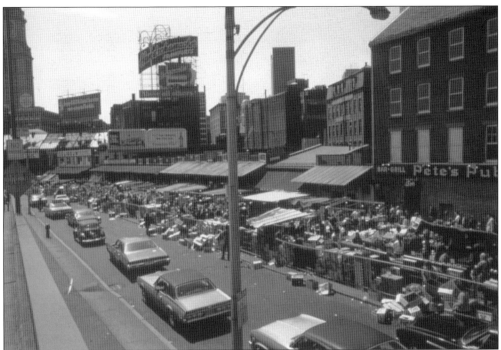

Between 1970 and 1980, Haymarket faced major political challenges. In a July 24, 1977, *Boston Globe* article titled "Haymarket Due for a Facelift," Richard Hogan, head of the Neighborhood Business Program, compared Faneuil Hall Market and Haymarket: "Haymarket is folksy, inelegant, and physically ugly. Quincy Market is the beautiful indulged sister; Haymarket is the deprived homely stepsister." He went on to say, "The facades of the Blackstone Street buildings are worn and unkempt looking. Rusted sheet metal serves as street awning. Where glass should be, plywood boards up windows. Skeletons of old signs pockmark the top of buildings. The overall color of the area is a dingy dark brown." (Both, courtesy of the National Archives 412-DA-7560, 412-DA-7547.)

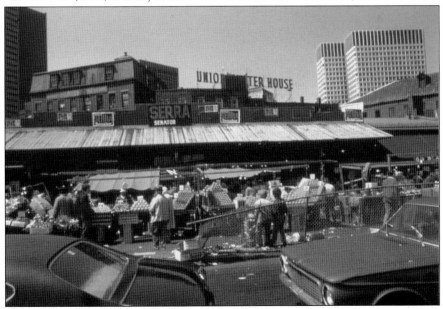

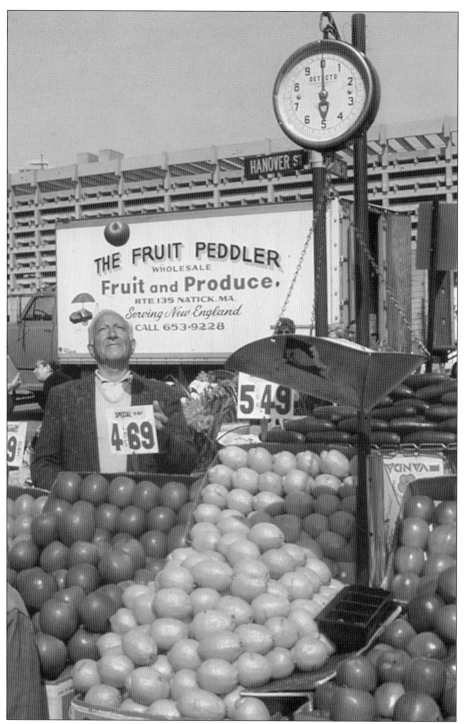

Here at the corner of Hanover and Blackstone Streets, with the Government Center Garage in the background, Peter H. Dreyer captures a vendor with time on his hands. The market rush comes in spurts, leaving a lot of downtime. Note what this vendor is doing to entertain himself and perhaps attract customers. (Courtesy of Peter H. Dreyer and City of Boston Archives.)

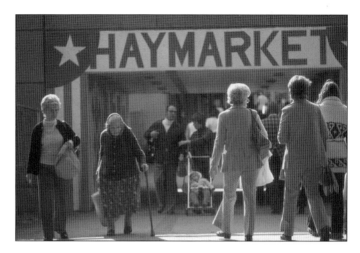

Photographer Lou Jones was born in 1945 and raised in Washington, DC. He began his photography career in 1971 and often photographed Haymarket, its customers, and its workers. This 1975 image captures shoppers going through an underpass of the Central Artery connecting downtown and Haymarket with the North End. (Courtesy of Lou Jones, © Lou Jones Photography.)

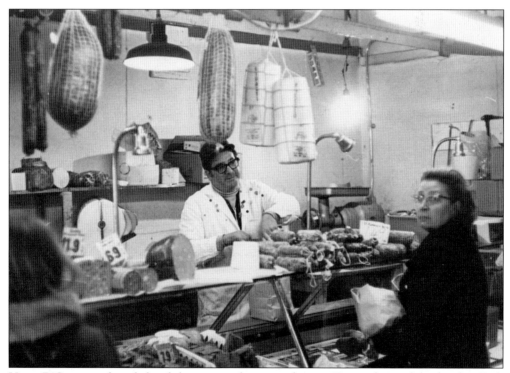

Harry D'Orsi, seen here behind the counter, began working at Haymarket with his brother Dick selling cold cuts in the 1960s. Harry opened his own shop, Harry's Cheese and Cold Cut Center, in 1968, moving to various locations until he set up at 80 Blackstone Street. He moved temporarily to 98 Blackstone Street while number 80 was repaired when it was destroyed by fire. The business has been at 98 Blackstone Street ever since, becoming a staple of the market. His future son-in-law Roy Fournier began working part-time in the late 1970s, married Harry's daughter Lisa, and took over in 1999. Harry continued to work until 2002 and passed away in 2008. The shop continues to welcome Haymarket customers to this day. (Courtesy of Roy and Lisa Fournier.)

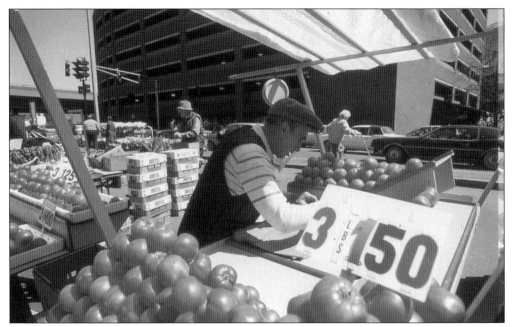

In April 1988, photographer Lou Jones captured a man organizing his pushcart full of tomatoes on a sunny day on Blackstone Street. In the background, cars are stuck in traffic on North Street going toward the Central Artery. Today, this is still a relatively familiar scene. (Courtesy of Lou Jones, © Lou Jones Photography.)

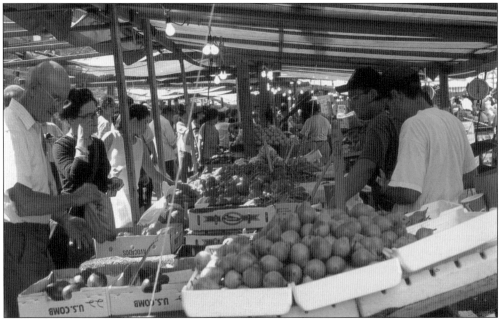

Haymarket thrived after Big Dig construction, as seen in this August 1999 photograph by Lou Jones. The changing demographic of the customers, buyers, and sellers is apparent in this scene, as the market shifted into a melting pot of consumers from diverse backgrounds. This change is also reflected in different types of produce as well. (Courtesy of Lou Jones, © Lou Jones Photography.)

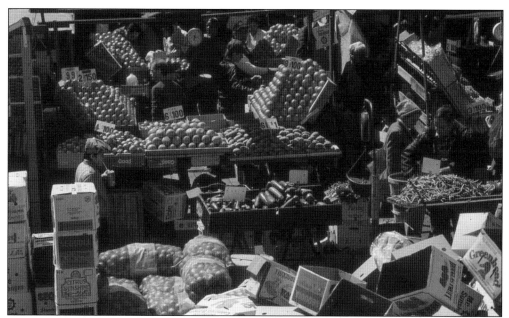

This April 1988 image by Lou Jones illustrates the replacement of the pushcarts by temporary stands with canvas and tarp awnings that protected the vendors and the produce from sunlight, rain, and snow. This year was especially important in Haymarket's history, as the final design process for the Big Dig was under way. (Courtesy of Lou Jones, © Lou Jones Photography.)

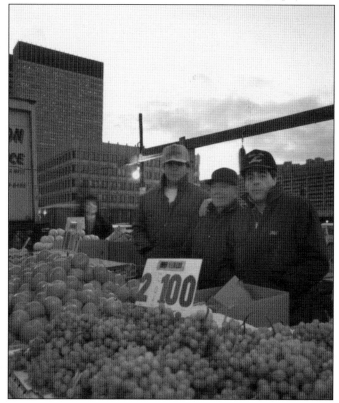

This January 1988 image was captured by photographer, author, and teacher Peter Vanderwarker, whose work is frequently exhibited in museums and galleries and can be found in the collection of the Museum of Fine Arts, Boston. Behind these produce vendors at the corner of Blackstone and Union Streets is the John Fitzgerald Kennedy Federal Building on the left and the Government Center Garage on the far right. (Courtesy Peter Vanderwarker, © Peter Vanderwarker Photographer.)

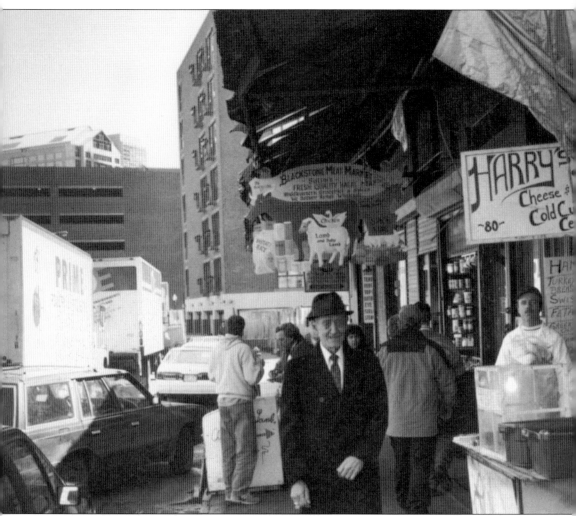

This streetscape of Blackstone Street looking toward North Street illustrates major changes to the landscape between the late 1970s and the 1980s. At the far end of North Street, the new Deck Square Parking Garage can be seen on the left, and on the end of Blackstone Street, in the center, the Millennium Bostonian Hotel is visible on the site of the Coliseum Restaurant. Roy Fournier, owner of Harry's Cheese and Cold Cut Center, is seen here in 1988 standing in front of his store, which is still in business today at 98 Blackstone Street. (Courtesy of Peter Vanderwarker, © Peter Vanderwarker Photography.)

Eight
THE BIG DECADE, MID-1990S TO MID-2000S

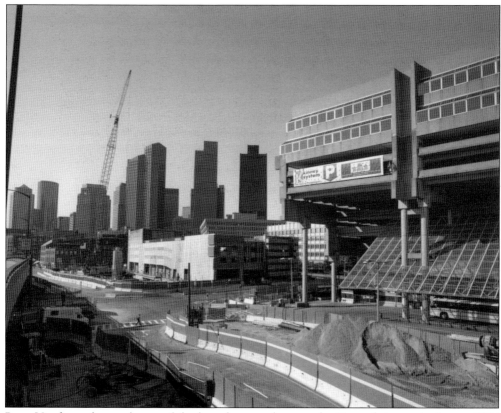

Peter Vanderwarker took one of the last photographs atop the Central Artery in August 1998 looking toward the corner of Sudbury and Blackstone Street. That year was the peak of Big Dig construction, and during this time, new structures were planned and developed for the former route of the Central Artery, including the building shown in the center of the photograph at 136 Blackstone Street. This building would eventually house the MBTA Haymarket Subway Station, the Massachusetts Registry of Motor Vehicles, and the Boston Public Market. On the right is the Government Center Garage and the MBTA Haymarket Bus Station. (Courtesy Peter Vanderwarker © Peter Vanderwarker Photographer.)

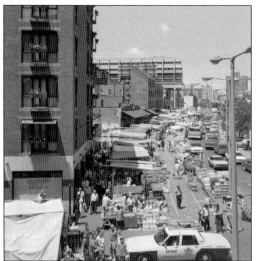

A 1991 photograph taken by Peter Vanderwarker shows Haymarket with the Central Artery at the top right of the image. That same year, the Boston Redevelopment Authority released "Boston 2000: A Plan for the Central Artery," which included the plan and zoning for the city's Central Artery Air-Rights Park System in the heart of downtown, a project created out of reclaimed land made available through the depression of the existing highway. The new zoning, known as "Article 49," allowed for development and open space for all parcels from North Station to Chinatown, an area, now known as the Rose Kennedy Greenway Conservancy. (Courtesy Peter Vanderwarker © Peter Vanderwarker Photographer.)

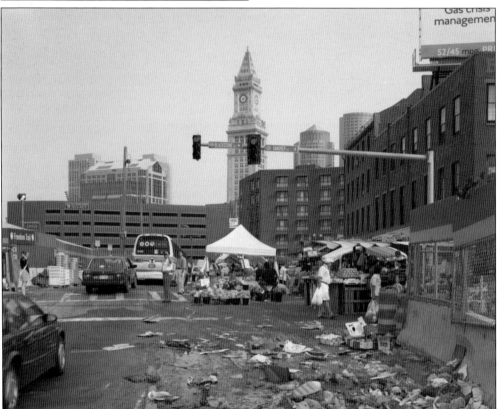

Peter Vanderwarker documented the persistent problem related to trash collection in this August 2001 image. The Haymarket Pushcart Association working with the North End/Central Artery Task Force addressed this problem by proposing that a trash compactor be placed on Parcel 9, the triangular area of land between the Surface Artery and Blackstone, Hanover, and North Streets. While this was accepted, lobbying efforts for the widening of sidewalks along Blackstone Street and a retractable roofs system for the stalls were unsuccessful. (Courtesy Peter Vanderwarker © Peter Vanderwarker Photographer.)

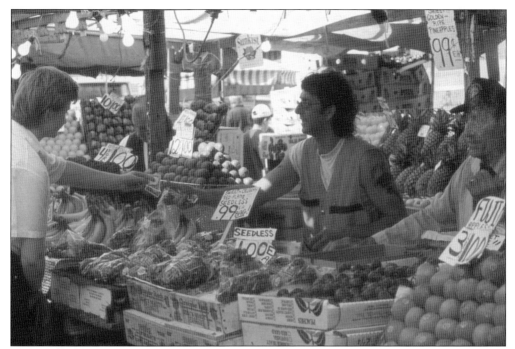

These images by Lou Jones illustrate how Haymarket adapted to societal changes with the sale of organic produce and what once were considered exotic fruits. The shoppers reflect the changing demographics of the city. When these photographs were taken in August 1999, the process of selecting developers for building parcels made available by the Big Dig was under way. Area residents and the Haymarket Pushcart Association were worried about development and its effect on parking in the Blackstone Street area, a chief concern being the future of Parcel 9, which was slated to be the site of a new building. (Both, courtesy Lou Jones © Lou Jones Photography.)

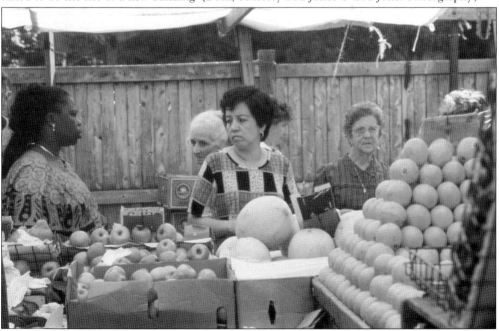

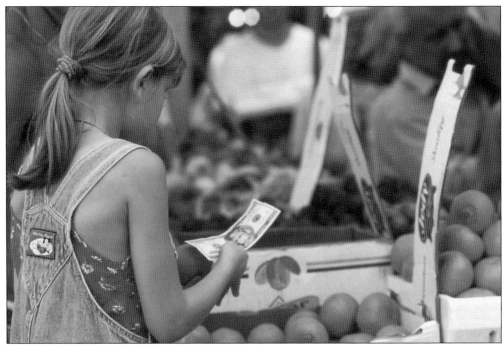

Young people have always been a part of the Haymarket way of life. Lou Jones captured a girl engaged in her family's produce business on Blackstone Street. Throughout Haymarket's history, children have worked with their parents and grandparents in order to make a living for the families. It was, and still is, not unusual for an older generation to pass down their businesses at Haymarket to their children. Some vendors and workers want a better life for their children and work to give them the opportunity to explore other ways of life. (Both, courtesy Lou Jones © Lou Jones Photography.)

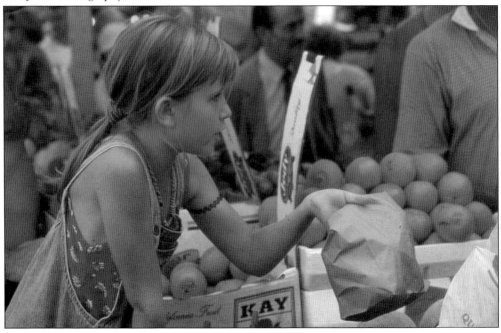

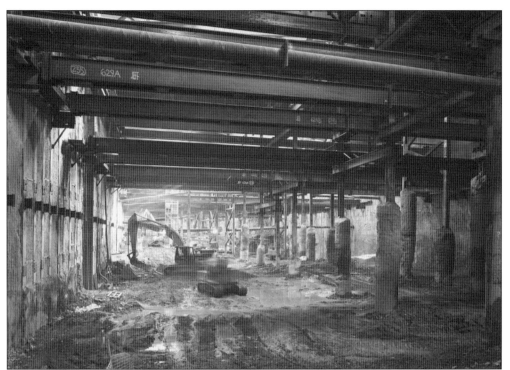

Photographer Peter Vanderwarker captured the essence of the Big Dig in these two images of the underground construction from 2000. They show the scale of Boston's Big Dig project. The Big Dig was one of the most challenging and technically difficult construction endeavors in the history of the United States. The Massachusetts Department of Transportation's official website states that the Big Dig "replaced Boston's deteriorating six-lane elevated Central Artery (I-93) with an eight-to-ten lane state-of-the-art underground highway, two new bridges over the Charles River, extended I-90 to Boston's Logan International Airport, and Route 1A, created more than 300 acres of open land and reconnected downtown Boston to the waterfront." (Both, courtesy Peter Vanderwarker © Peter Vanderwarker Photographer.)

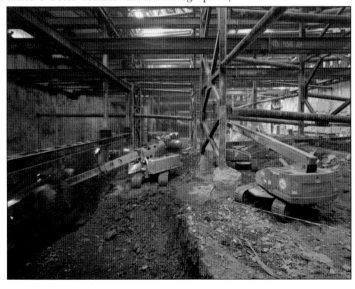

Peter Vanderwarker photographed this panoramic image of Boston that stretches from the Mercantile Wharf Building on the far left to Boston City Hall on the far right. In the background, off center to the left, is the iconic Custom House Tower, and the tall buildings to the right of it are part of Boston's Financial District. Haymarket, visible just below the off-ramp to the Central Artery, curving around Blackstone and Hanover Streets, seems almost dwarfed by the development in this area. Visible to the right is Union Street looking toward Faneuil Hall. The

cluster of trees parallel to Union and Congress Streets is Carmen Park, now the site of the New England Holocaust Memorial. The park was named in recognition of William Carmen for his leadership in creating the memorial. The bottom of the image shows a vacant lot used by the city for parking, but it in turn would be developed in the near future. (Courtesy Peter Vanderwarker © Peter Vanderwarker Photographer.)

Steel and concrete pilings dominate the frame in Peter Vanderwarker's 2000 photograph of the construction of the Thomas P. O'Neill Jr. Tunnel. The tunnel followed roughly the same route as the Central Artery, which it replaced. Named after Thomas P. O'Neill Jr., longtime Speaker of the US House of Representatives, the tunnel opened in 2005. In 2004, the Rose Kennedy Greenway Conservancy was established to oversee the development of the Rose Kennedy Greenway on land reclaimed by the demolition of the Central Artery. Following the Big Dig project, the North End was no longer cut off from the rest of the city. (Courtesy Peter Vanderwarker © Peter Vanderwarker Photographer.)

In 1976, artist Mags Harries installed bronze pieces of "trash" at Haymarket. Photographer Peter Vanderwarker documented the piece called *Asaroton*, meaning "un-swept floor." The title is a reference to ancient Roman floor mosaics and pays homage to the debris that covers Haymarket during its hours of operation on Fridays and Saturdays. During the Big Dig project, Harries's installation was temporarily relocated to the Museum of Science in Boston. Following the completion of the Big Dig, the piece was rededicated in 2006 and remains in place to this day. (Courtesy of Peter Vanderwarker, © Peter Vanderwarker Photography.)

Nine
HAYMARKET TODAY

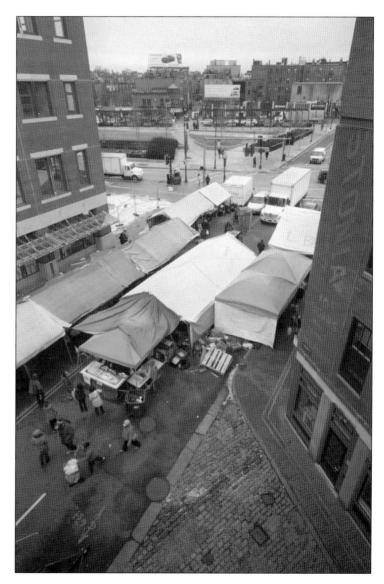

All the photographs in this chapter were taken by photographer Justin Goodstein as part of Historic New England's Haymarket Project. Today's market runs along Blackstone, North, and Hanover Streets, three sides of the historical Blackstone Block. The cobblestoned Marshall Street can be seen at the bottom right of this image looking toward the Rose Kennedy Greenway and the North End. The narrow alley was donated to the town in 1652 by Thomas Marshall, and it is the first street in the block to appear in town records. (Courtesy of Historic New England.)

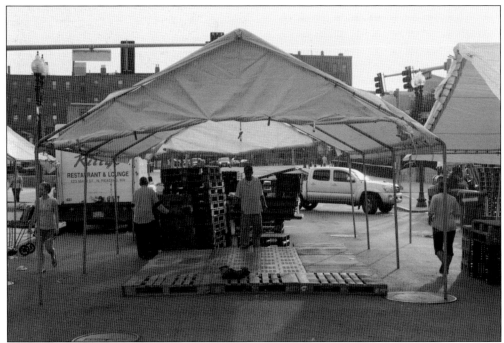

Joseph Onessimo, known to everyone as Joey O, describes a typical setup: "Some guys set their stands on Thursday . . . I get up at 3:30 Friday morning. I come to the Chelsea Market. I check on my produce, I make sure I have everything. I call my driver. He picks [the produce] up and delivers it down the market, and at six o'clock I start setting my stand up . . . I work all day 'til six, seven at night, close up, come back the following morning [at] five o'clock and work till I sell out. And that's it. That's my weekend." (Both, courtesy of Historic New England.)

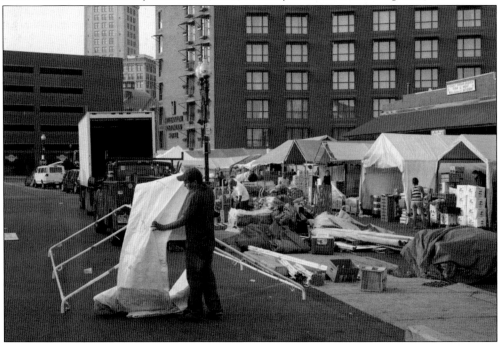

The luxury Millennium Bostonian Hotel near Quincy Market and Faneuil Hall, at the corner of North and Blackstone Streets, stands over the crowds and noise on market days. In previous decades, the pushcart vendors wrapped all around this block of North Street. Today, the stands go only to the entrance of the hotel about halfway up the block. (Courtesy of Historic New England.)

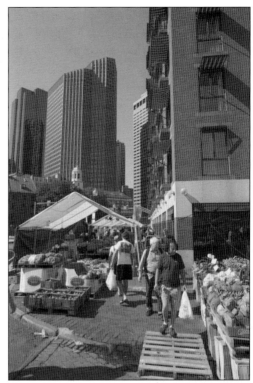

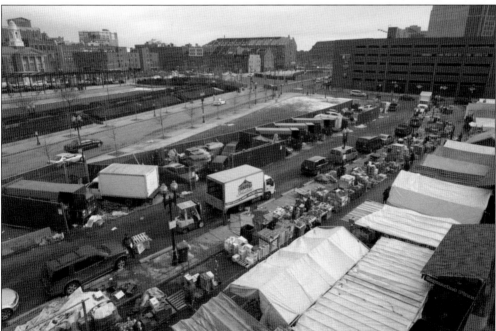

Vendors often set up so they can sell from both the front and back of their stands. Extra produce is stored on pallets like these along Blackstone Street. The Haymarket Pushcart Association worked closely with the City of Boston to streamline trash collection, greatly enhancing the cleanliness of the market. (Courtesy of Historic New England.)

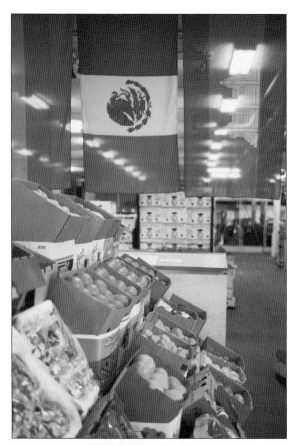

The New England Produce Center, also known as the Chelsea Produce Market, is one of the country's largest wholesale produce markets. Located on Market Street in Chelsea, Massachusetts, it is convenient to the Grand Junction Railroad and truck links via I-93 and Route 1. The market is home to more than 40 produce vendors, or as the Haymarket vendors refer to them, "houses." Haymarket's Otto Gallotto sums up the relationship, "Without the New England Produce Center . . . I mean, they're our big brothers, we can't survive." (Both, courtesy of Historic New England.)

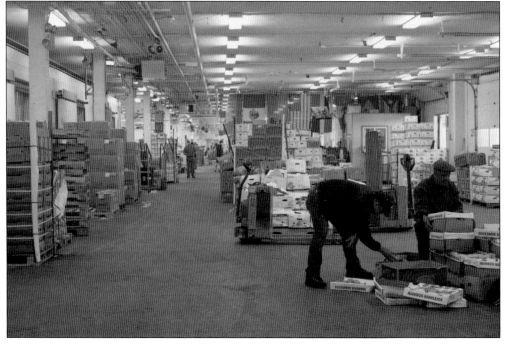

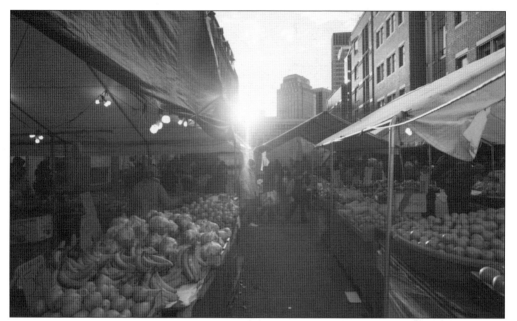

Morning is the quietest time for the market. As the sun rises over Government Center, the stands are bursting with produce ready for the onslaught of customers. By the end of Saturday, most of the goods will be sold. This is when the biggest bargains can be found, when the fruit and vegetables that vendors cannot store are sold in bulk for a fraction of their original price. (Courtesy of Historic New England.)

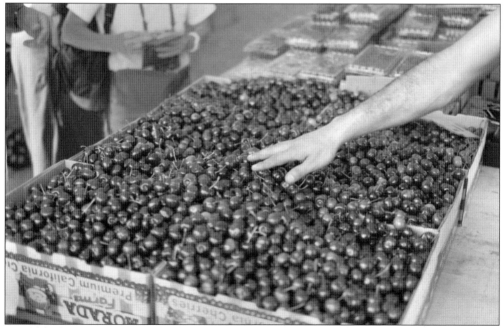

"Now you can have cherries all winter. You can have grapes all winter. You can have plums all winter. At one time you didn't have that stuff . . . in the sixties, seventies, when I was a kid. We had cherries two months a year. We had plums three months a year. And now you can get that stuff around the clock," according to Joey "O" Onessimo. (Courtesy of Historic New England.)

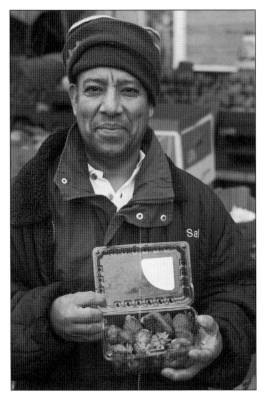

Today's market workers come from backgrounds as diverse as the produce they sell. These workers often have two or more jobs with schedules that allow them to work the long hours of the market: set up Thursday, sell goods on Friday and Saturday, then break down the stalls and clean the street late on Saturday. One can still find Italian workers who are here through family or neighborhood connections. More and more workers hail from Central America, the Middle East, Russia, and Asia. Some are recent immigrants; some are the second generation. Some stay for a short while, others for life. (Both, courtesy of Historic New England.)

Alyssa "Sina" Chhim came from Battambang, Cambodia, in 1982. She began working for Otto Gallotto at his stand, and later she worked at Harry's Cheese and Cold Cut Center. Chhim says, "I like to work outside because you see more more crowd, more people. I want to rent a spot for my kids. I got five of them. Got to put them in work!" Sina got her own stand in October 2014. (Courtesy of Historic New England.)

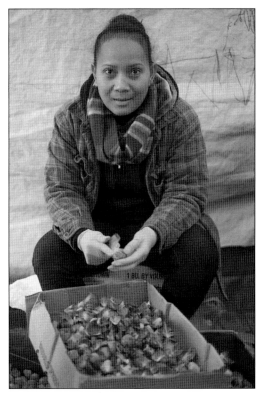

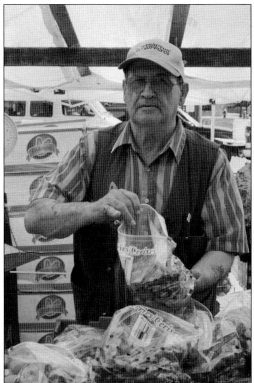

Joey O grew up in the North End and got involved with the market more than 60 years ago. He recalls, "I used to go peddle out in the street with a pushcart, with a horse and team, and I used to peddle with a truck. I used to do a lot of peddling through the South End . . . and on the weekends I worked Haymarket." (Courtesy of Historic New England.)

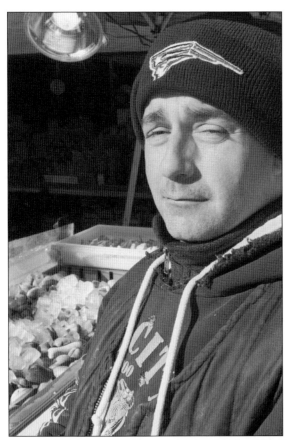

Haymarket has had a number of fish markets over the years, in shops along the market, in pushcarts, and now in stands. North Street had several vendors, but with the arrival of the Bostonian Millennium Hotel, the stands moved to Hanover Street. Fishy Joe works at a stand that specializes in oysters and clams. (Courtesy of Historic New England.)

A quintessential Boston Irish pub on Blackstone Street, Durty Nelly's succeeded Pete's Pub, a longtime market establishment. Pete's was also known as a watering hole for city employees who used a back door to enter the second floor unseen for liquid lunches. (Courtesy of Historic New England.)

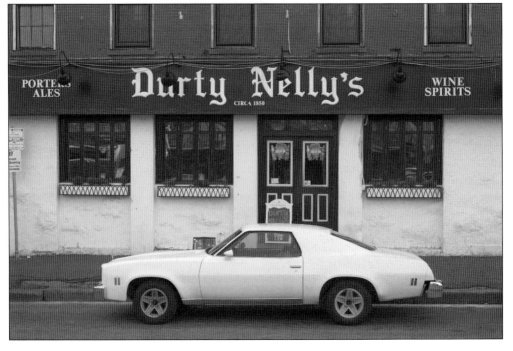

Scott Lambert's grandfather started the Puritan Beef Company in 1911 when he came to this country from Russia. Scott's father took it over in the 1940s, and Scott has been running the business since his father retired. He has been at the market for close to 50 years. (Courtesy of Historic New England.)

"I started when I was twelve years old . . . It was a very hard life . . . we work all year round, so it can be ten degrees and we would be working outside. Many a time I would pick up a piece of meat and it would instantly freeze to my hand," recalled Scott Lambert. (Courtesy of Historic New England.)

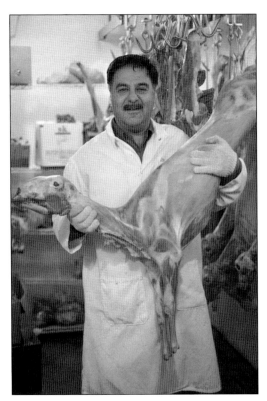

Salim Marhamo came to the United States in 1988 from Beirut, Lebanon. He asked people where to shop for vegetables, and everyone told him to go to Haymarket. He saw that many Muslim immigrants were coming to market "so, I started a specialty halal meat store," he said. "It was convenient for a lot of the Muslim community because they are coming here to get their vegetables." (Courtesy of Historic New England.)

"Nothing surprises me . . . I get people that come in with suits and ties on, and I've got people that come in and they've got no shoes on . . . They're walking around the market, middle of winter; they've got shorts on. I'm standing here, I've got four sweatshirts on, and my long johns on, and this guy walks in with a T-shirt," mused Roy Fournier, owner of Harry's Cheese and Cold Cut Center. Fournier's business, in a WGBH poll of best places in and around Boston (Boston A-List), was voted the number one cheese shop. (Courtesy of Historic New England.)

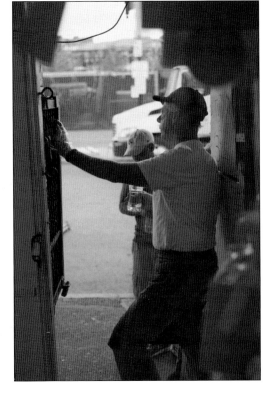

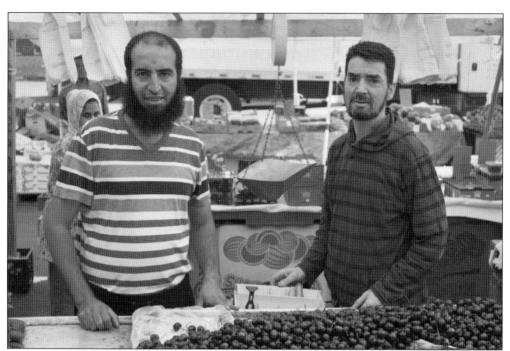

Hassan Elsharkawr (above left) came to America from Egypt in 2008. A neighbor brought him to Haymarket and introduced him to people. He got a job as a worker and eventually his own spot. He met his wife, Moroccan immigrant Merien Chahbouni (right, back to the camera), in America, and she worked with him when he first got his stand. When Hassan needed an operation and was out for several months, Merien ran the stand on her own. Now she raises their three young children at home and helps at the market when she can. (Both, courtesy of Historic New England.)

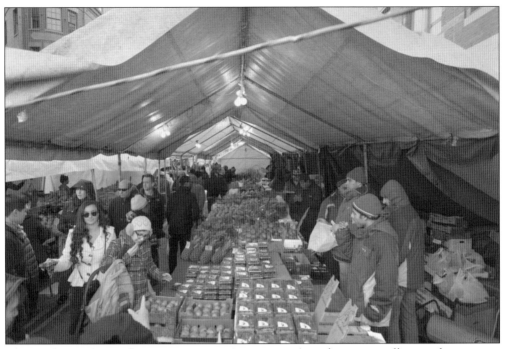

At its busiest, usually over the lunch hour, the crowds can be three-people deep. Office workers on lunch breaks rub shoulders with tourists, and customers with shopping carts jostle with mothers balancing groceries and children, all looking for the best bargain. One can hear the vendors shouting, customers haggling, and languages from all over the world being spoken. (Courtesy of Historic New England.)

The selection at the market depends on what is available at the New England Produce Center, which also supplies all the area's supermarkets. With more and more new immigrants living in the city and working the market, the variety of produce has grown in the last two decades. Many stands stock more than 50 items, including more Asian and Hispanic produce. (Courtesy of Historic New England.)

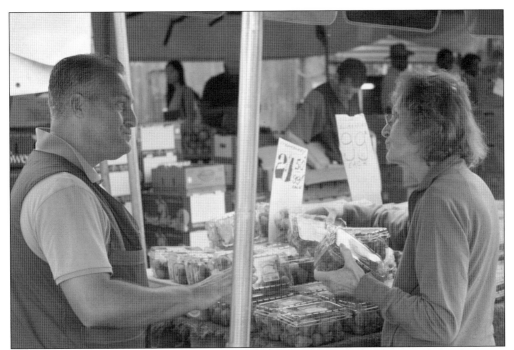

Otto Gallotto is president of the Haymarket Pushcart Association. He works closely with the city on issues of development, trash collection, and—most pressing to the owners of the 196 vendor licenses—the lack of parking. To Gallotto, Haymarket is about relationships: between the association and the city, among the members of the association, with shop owners on Blackstone Street, and between vendors and their customers. (Courtesy of Historic New England.)

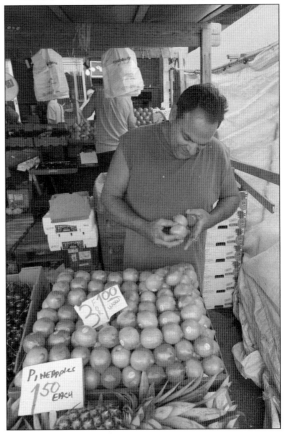

Jesse Holler recalls skipping school on Fridays in the 1970s to work the market, making $35 for two days. "We sat there all day with a bucket of water and wiped the dust off the oranges . . . I cleaned hundreds and hundreds and hundreds of oranges. The customers used to say, 'Aren't you supposed to be in school?' And I used to tell them, 'No, I got special permission to be down here.' " (Courtesy of Historic New England.)

Gus Serra remembers the difficulty of working in the summers: "We'd rent stands or refrigerators downstairs. If you had things that were very susceptible to the heat, you know, strawberries, blueberries—those kinds of things would die in the sun very quickly . . . and you had a lot more product to get rid of, because the terminals were pushing more product on you because the growing season was in full bloom." (Courtesy of Historic New England.)

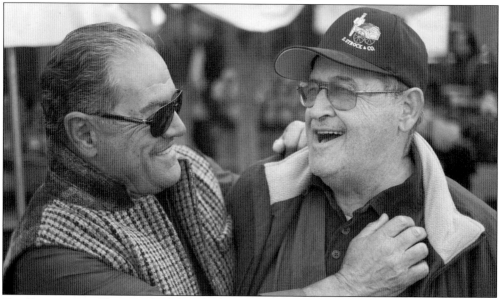

Gus Serra, pictured here on the left with longtime friend Joey O, no longer works at the market, although he owns two licenses and rents them out. The first president of the Haymarket Pushcart Association in 1974, he is also a former state representative and director of strategic planning at the Massachusetts Port Authority. Today, Serra works closely with Otto Gallotto and the Haymarket Pushcart Association as an advisor and intermediary with the city. (Courtesy of Historic New England.)

Retired vendor Frank Pennacchio still stops by every week to help as needed, chat with friends, and grab a beer at Durty Nelly's. He got his start at the market during World War II. Living with nine siblings in the North End, he remembers looking for discarded wooden boxes his family could burn for fuel. "And before you knew it they hired you. They gave you a quarter, a half a dollar, a dollar a day." (Courtesy of Historic New England.)

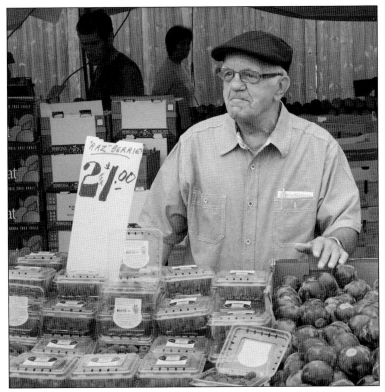

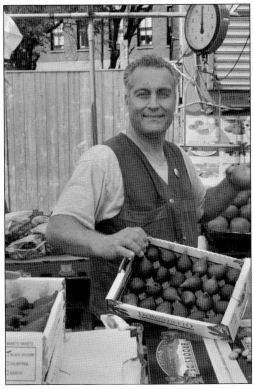

"I have a routine of going to the same people [The New England Produce Center] every week. I don't like changing the houses that I go to. I think my reputation stands for itself. I've been doing business with people since the beginning, when I first started, and they'll always have cantaloupe, honeydew, vegetables, peppers, even with the carrots—I'll have it every week, because people know Otto sells this. If there's a fig, I try to buy figs. I mean, I try to buy certain stuff that the Italians might like, too, because that's what I know," said Otto Gallotto. (Courtesy of Historic New England.)

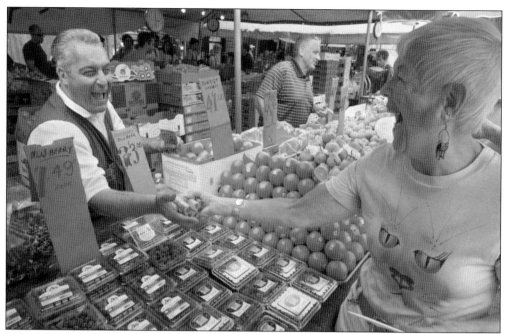

"There's a woman who comes every week with rolls of quarters, and her name is Avril. And she'll come by and say, 'Hey Otto, how many rolls of quarters do you need?' And it's a routine, week after week. She'll come down with two, three hundred dollars' worth of quarters for everybody down the market!" stated Otto Gallotto. (Courtesy of Historic New England.)

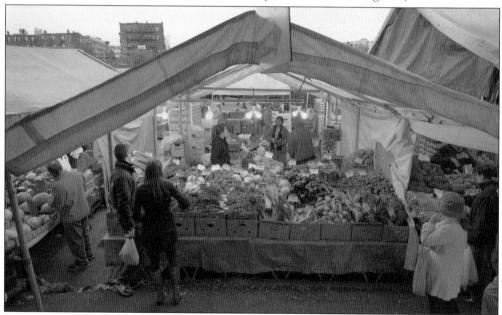

By the afternoon, the market's first rush has died down. This gives the vendors time for a break, but more importantly it gives them time to restock from the lunchtime crowds and prepare for customers who stop by on their way home from work. Although the pushcart vendors stay open later, most shops along Blackstone Street close at 5:00 or 6:00 p.m. (Courtesy of Historic New England.)

Cleaning up the market, a big chore, is part of the weekly cycle that is Haymarket. Thanks to the efforts of the Haymarket Pushcart Association, the Department of Public Works, and the Department of Inspectional Services—what Otto Gallotto calls the triumvirate—the cleanliness of the market has greatly improved. (Courtesy of Historic New England.)

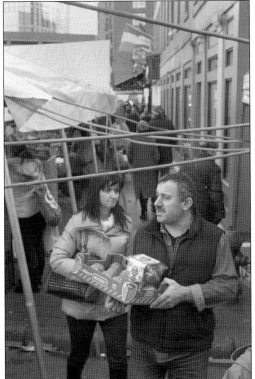

Customers carry their purchases at the corner of Blackstone and North Streets. The market is convenient to the Haymarket stop on the MBTA's Green and Orange Lines and the bus terminal on Blackstone Street. One of the little-known facts about Haymarket is that vendors can validate parking for shoppers at the Parcel 7 Parking Garage on Blackstone Street. (Courtesy of Historic New England.)

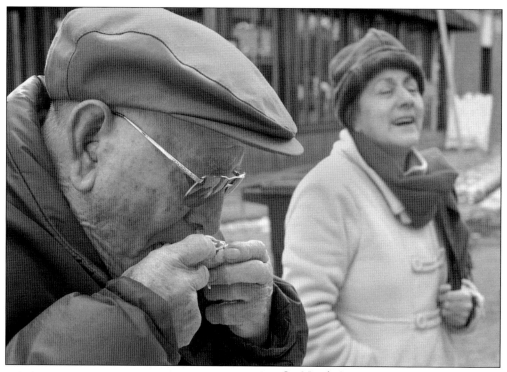

On North Street, one can usually find two fish stands but only in the cool weather, not to be seen in the heat of the summer. When they are open, one can see passersby lining up (and enjoying) the fresh-shucked seafood at one of the stands. (Courtesy of Historic New England.)

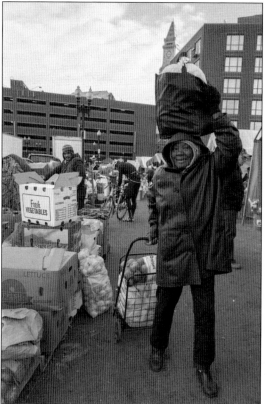

The back aisle of Haymarket facing the Rose Kennedy Greenway is not only used for storage. Vendors often operate out of both sides of their stands, running back and forth between customers. People often stock up with produce for the week for themselves and their families. Owners and staff from smaller restaurants also are big customers of the market. (Courtesy of Historic New England.)

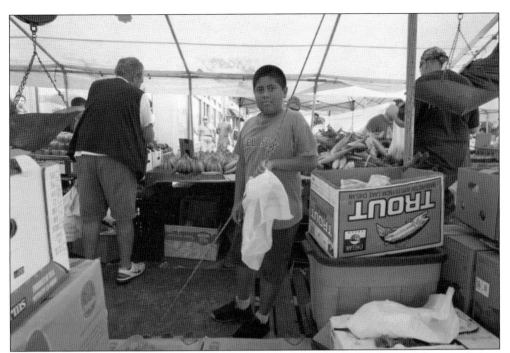

Children have always worked at the market, whether for pay or just helping out. They are often on cleaning duty, but many of them are just as good at selling. Since many of the stands are family businesses, everyone is expected to pitch in when needed. Saturdays and summer vacations are often when one will find children at work. Here, Dani Majano helps out at his father, Oscar's, stand. (Courtesy of Historic New England.)

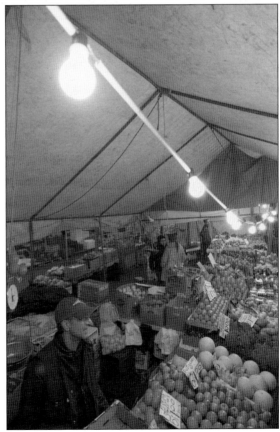

Working on a brisk fall evening, vendors selling produce are seen inside of large tents that line Blackstone Street. The tents are all interconnected during the colder months, creating a small tunnel from one produce seller to the next, thus saving on the cost of large gas heaters that provide warmth in the dead of winter. Lights hang low, and scales are strung to the supporting structure of the tents, within easy reach of the seller. (Courtesy of Historic New England.)

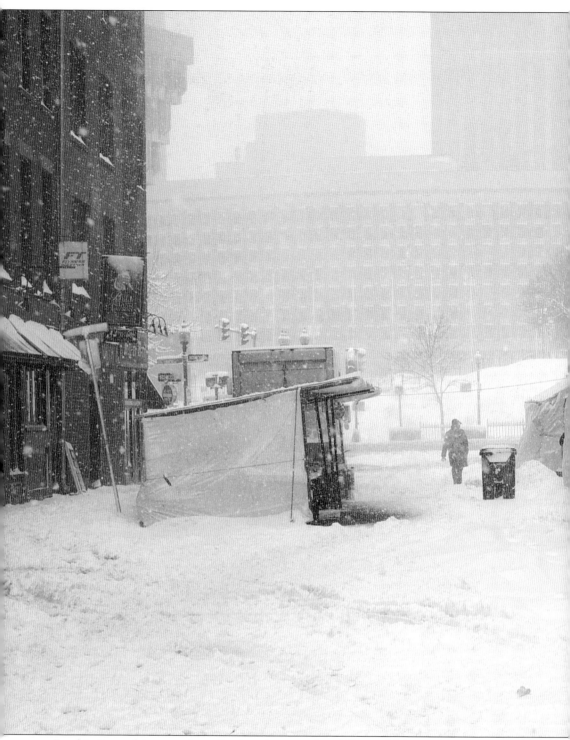

Frankie Pennachio remembers, "In the winter you froze! You couldn't use gloves to work so you just froze. I mean you were cold. You had these big barrels, metal barrels . . . you put all your wood in the barrel and you burned that. That was your heat. You went home smelling of smoke." The

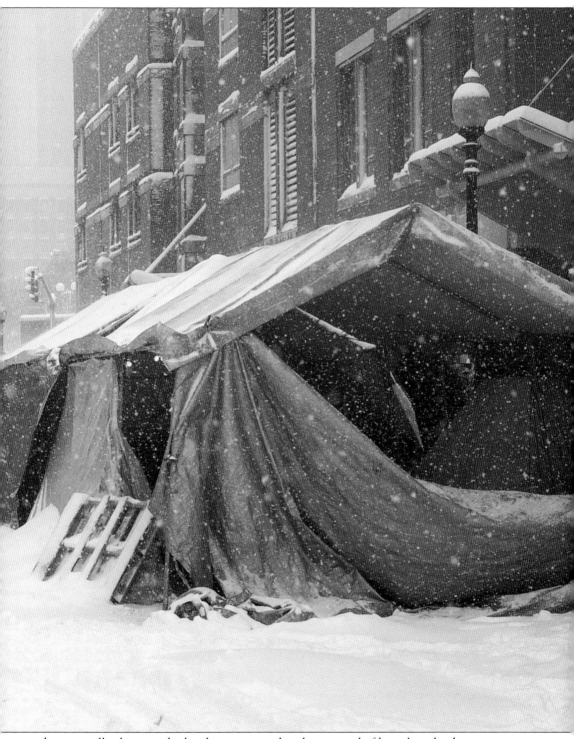
vendors are still subject to the harsh winter weather, but instead of burn barrels, they now use electric heaters. (Courtesy of Historic New England.)

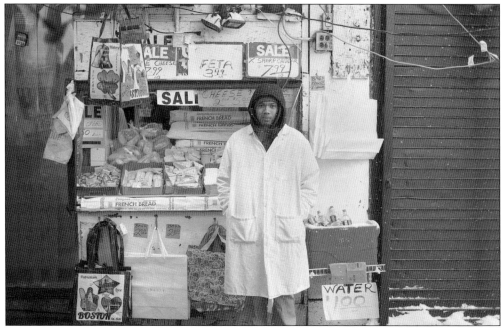

Jonathan Chhim, Alyssa Chhim's son, began working at Harry's Cheese and Cold Cut Center on Blackstone Street while he was a student. He often worked the outdoor stand while his mother worked inside. He says he "was shy at first but after a few weeks got comfortable. It was fun but on days when it was slow, cold, or raining and people don't show, it was brutal." (Courtesy of Historic New England.)

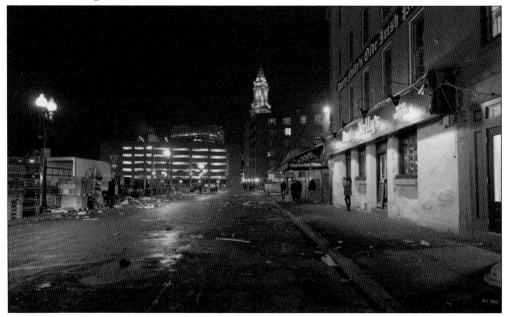

Having trash compactors has made cleaning up much easier. Stands come down Saturday evening, and then Jim Ruma and his crew come and take away all of the wooden pallets. By Saturday night, the last of the cleaning is done, and Blackstone Street is ready for traffic and regular business. (Courtesy of Historic New England.)

Ten
THE FUTURE OF THE MARKET DISTRICT

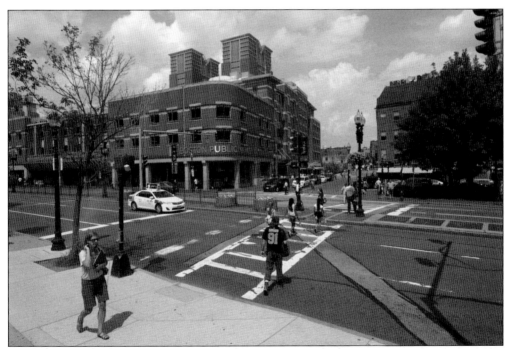

The Boston Public Market opened to the public on July 30, 2015. Located at the MBTA's Haymarket Station, between Congress Street and the Rose Kennedy Greenway and adjacent to Haymarket, the market is devoted exclusively to produce, food, and wares produced in New England. (Courtesy of Justin Goodstein.)

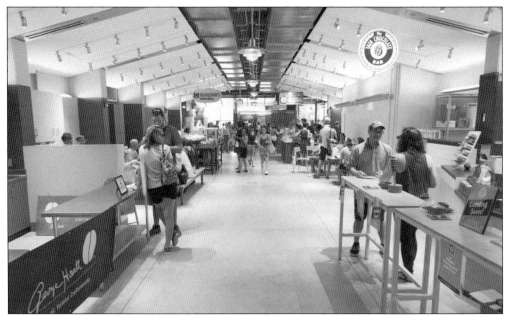

In the second half of the 20th century, the market district contracted. This was due to many factors, including the produce center moving out of Quincy Market, changes in people's shopping habits with the rise of the supermarket, the loss of half of the shops and vendors on Blackstone Street due to the Central Artery, and further reduction of the market in size during the Big Dig. This all changed in July 2015 with the opening of the Boston Public Market. (Courtesy of Justin Goodstein.)

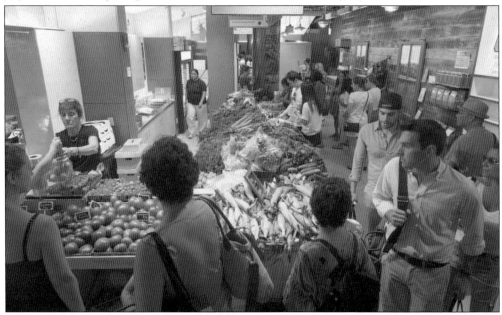

The Boston Public Market is a year-round locally sourced market, the first of its kind in the United States. The Boston Public Market Association, a not-for-profit institution, worked with its architectural partners at Architerra to develop the building, which they envisioned not only as a market selling the best the region as to offer from farmers, fishermen, and specialty food producers, but also as a new civic institution. (Courtesy of Justin Goodstein.)

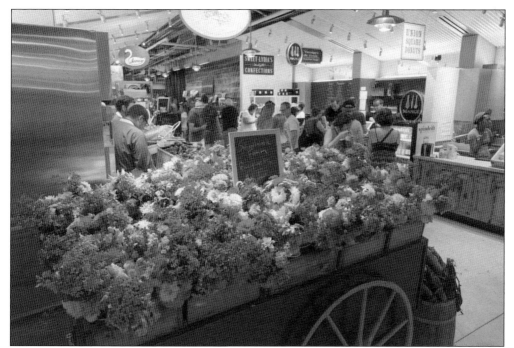

In a ribbon-cutting ceremony on July 30, 2015, the *Boston Globe* reported that Gov. Charlie Baker said, before cutting the ribbon with Mayor Martin J. Walsh and market officials, "It's a great day for Boston. It's a great day for farmers and food providers in Boston." (Courtesy of Justin Goodstein.)

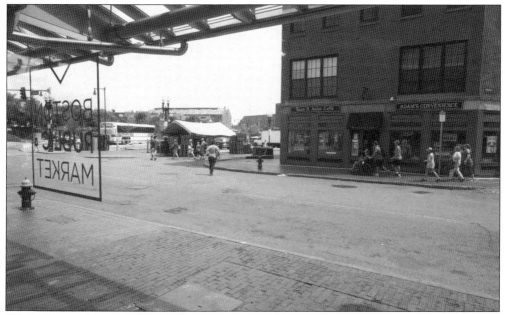

While the new Boston Public Market is a welcome addition to the market district, it is important to remember the role of Haymarket and its significance to Boston. As seen through the window of the Boston Public Market, Haymarket begins its weekly cycle of stands being assembled and produce being delivered. Soon shoppers from all over Boston and the region will descend upon Haymarket, a Boston tradition. (Courtesy of Justin Goodstein.)

BIBLIOGRAPHY

"200-Year-Old 'Pushcart Club' Finds It's Time to Organize." *Boston Globe*, November 23, 1974.
"Boston Pushcart Peddlers." *Boston Globe*, August 22, 1904.
Benes, Peter. "Of Time and Markets." *Boston Globe*, September 15, 1968.
Bowen, Abel. *Bowen's Picture of Boston: Or the Citizens and Stranger's Guide to the Metropolis of Massachusetts and Its Environs*. Boston, MA: Otis, Broaders and Company, 1838.
Proceedings of the Bostonian Society at the Annual Meeting, January 11, 1910. Boston, MA: Bostonian Society, 1910.
Gomez-Ibanez, Miguel. "Preserving Three Hundred Fifty Years of Change in the Blackstone Block." *Old-Time New England* (Summer/Fall 1977), Vol. 68, No. 249: 19–31.
Limbach Lempel, Diana. "Producing Authenticity: Redevelopment and Boston's Haymarket." Master's thesis, Harvard University Graduate School of Design, 2012.
Porter, Edward Griffin. *Rambles in Old Boston, New England*. Boston, MA: Cupples and Hurd, 1887.
Quincy, John Jr. *Quincy's Market: A Boston Landmark*. Boston, MA: Northeastern University Press, 2003.
Quincy, Josiah. *A Municipal History of the Town and City of Boston During Two Centuries from September 17, 1630 to September 17, 1830*. Boston, MA: Charles C. Little and James Brown, 1852.
"Sidewalks Are Cleared, No Longer Same Old Market Scenes." *Boston Globe*, January 5, 1905.
Snyder, Wendy. *Haymarket*. Boston, MA: MIT Press, 1970.
Sweetser, M.F. *King's Handbook of Boston Harbor*. Boston, MA: Moses King Corporation, 1889.
"The Central Artery/Tunnel Project–The Big Dig." The Big Dig. Accessed September 3, 2015. https://www.massdot.state.ma.us/highway/TheBigDig.aspx.
Thwing, Annie Haven. *The Crooked & Narrow Streets of the Town of Boston 1630–1822*. Boston, MA: Marshall Jones Company, 1920.
Trachtenberg, Alan. *Reading American Photographs: Images as History, Mathew Brady to Walker Evans*. New York: Hill and Wang, 1989.

About Historic New England

Historic New England serves the public by preserving and presenting New England heritage. Historic New England is a museum of cultural history that collects and preserves buildings, landscapes, and objects dating from the 17th century to the present. The organization offers something for everyone: access to historic sites spanning four centuries and five states, award-winning publications, landscapes ranging from formal gardens to farmland, and programs that explore the real stories of New England. Historic New England helps people develop a deeper understanding and enjoyment of New England life and an appreciation for its preservation.

DISCOVER THOUSANDS OF LOCAL HISTORY BOOKS FEATURING MILLIONS OF VINTAGE IMAGES

Arcadia Publishing, the leading local history publisher in the United States, is committed to making history accessible and meaningful through publishing books that celebrate and preserve the heritage of America's people and places.

Find more books like this at
www.arcadiapublishing.com

Search for your hometown history, your old stomping grounds, and even your favorite sports team.

Consistent with our mission to preserve history on a local level, this book was printed in South Carolina on American-made paper and manufactured entirely in the United States. Products carrying the accredited Forest Stewardship Council (FSC) label are printed on 100 percent FSC-certified paper.